M000236354

IMAGES
of America
GREELEY

ON THE COVER: Main Street (today's Eighth Street), pictured around the 1890s, was the core of the town's commercial district for several decades. A watering tank for horses anchored the intersection of Eighth Street and Ninth Avenue. The Greeley Electric Light Company, established in 1885, erected its power poles along the south side of Main Street. (City of Greeley Museums–Permanent Collection.)

IMAGES
of America

GREELEY

Peggy Ford Waldo with the
Greeley History Museum

ARCADIA
PUBLISHING

Copyright © 2016 by Peggy Ford Waldo with the Greeley History Museum
ISBN 978-1-4671-3346-3

Published by Arcadia Publishing
Charleston, South Carolina

Printed in the United States of America

Library of Congress Control Number: 2016949276

For all general information, please contact Arcadia Publishing:
Telephone 843-853-2070
Fax 843-853-0044
E-mail sales@arcadiapublishing.com
For customer service and orders:
Toll-Free 1-888-313-2665

Visit us on the Internet at www.arcadiapublishing.com

Everyone has stories to tell, and treasures to share. Nathan Meeker, in the December 7, 1870, edition of the Greeley Tribune, *encouraged Greeley's pioneers to collect and preserve natural specimens, artifacts and documents for posterity in the hopes that a museum could be organized in which to place a collection of common treasures that would be "both instructive and entertaining."*

This book is dedicated to the people of Greeley—natives, transplants, and transients! Meeker recognized the limitations of one and the power of many and said in his prospectus in the first issue of the Greeley Tribune, *November 16, 1870: "Individuals may rise or fall, property may be lost or gained. But the colony as a whole will prosper and the spot on which we stand will become the center of intelligence and activity." May you feel the energy of this remarkable community!*

CONTENTS

ACKNOWLEDGMENTS

Many have informed, inspired, pushed, humored, and supported me as I wrote this book, and I humbly extend my deepest appreciation and thanks to the following: Nathan Meeker, who knew Greeley's history would be unique and worthy of preservation; the Meeker Memorial Library Association, for preserving historical records starting in 1900; the City of Greeley, for supporting four museums to preserve and interpret the heritage of Greeley and northeastern Colorado; generous citizens who have donated historical photographs, documents, and artifacts that made the writing of this book possible; Dan Perry, museum manager, for his encouragement and belief in this project; amazing, helpful, knowledgeable, and patient colleagues Ashley Baranyk and Katalyn Lutkin for scanning images, along with Caroline Blackburn, JoAnna Stull, Melissa Gurney, Dyani Johnson, and Sarah Saxe; Susan Seager, friend, volunteer, history sleuth, and humorist, who helped select images and proofread the text; and finally, my husband, Rob, who recognizes that I am "tall on the inside" and capable of reaching for anything I might desire!

Unless otherwise noted, all images are from the City of Greeley Museums–Permanent Collection, and are archived in the Hazel E. Johnson Research Center at the Greeley History Museum. The center welcomes anyone searching for information about the people, places, and events in Greeley, Weld County, and northeastern Colorado. Contact the museums at www.greeleymuseums.com for additional information.

INTRODUCTION

Greeley, Colorado, was founded by Nathan Cook Meeker (1817–1879), a native of Ohio. An avid reader and independent thinker, Meeker left home at 17. During his life, he found work as a freelance writer, poet, novelist, philosopher, librarian, traveling salesman, storekeeper, farmer, journalist, newspaper publisher and editor, and Indian agent for the US government. During the 1840s, he was intrigued by the utopian ideas of Charles Marie Francois Fourier (1772–1837), a French socialist reformer. Fourier believed small agrarian communities based on cooperative ideals were preferable to large urban communities based on competition and industry. Meeker became Ohio's chief spokesman for Fourier's ideas, known as Associationism in America. In 1844, he married Arvilla Delight Smith (1815–1905), and the newlyweds became promoters and residents of the Trumbull Phalanx, a short-lived (1844–1847) Ohio experimental commune based on Fourier's ideas. It failed due to a poor location, lack of capital, uncooperative individuals and outbreaks of ague or malaria.

In 1866, Horace Greeley hired Meeker as the agriculture editor of the *New York Tribune*, and the family moved from Dongola, Illinois, where they had lived since 1857, to Brooklyn. In October 1869, a reporting assignment brought Meeker to Colorado Territory. He was smitten with the spectacular Rocky Mountains, the abundant natural resources, friendly, helpful and prosperous businessmen, and the opportunity to inexpensively purchase or homestead fertile tracts of land in a climate renowned for its pure air, moderate temperatures, and perpetual sunshine. This trip rekindled his dream of a utopian community in the West, void of the problems that plagued the Trumbull Phalanx. Back in New York, Meeker penned his ideas in an article, "A Western Colony," published in the *New York Tribune* on December 4, 1869.

The article, with Horace Greeley's endorsement, described the advantages of Colorado Territory, Meeker's plan for a colony, and the type of people he desired: literate and temperate individuals with high moral standards and money. He received over 3,000 letters from *Tribune* readers. Encouraged by this response, a meeting was held at the Cooper Union on December 23, 1869, in New York City, and 59 people joined Meeker's joint-stock colonization company, called the Union Colony No. 1. There were 737 individuals chosen as colonists between 1869 and 1871, and each paid a membership fee of $155. In February 1870, a locating committee came West and in April purchased 11,916 acres lying west of the confluence of the South Platte and Cache la Poudre Rivers for $59,970.88, which included filing fees for an additional 60,000 acres of government land. Greeley was platted in April, and its first elected trustees were Nathan C. Meeker, president; Robert A. Cameron, vice president; and Horace Greeley, treasurer.

In spite of many unforeseen challenges, Greeley, built on the "Great American Desert," quickly prospered, and grew from 480 people in 1870 to 1,149 by 1871. Greeley was the model for other Colorado colonies, including the St. Louis–Western Colony at Evans; the Chicago-Colorado Colony at Longmont; the Larimer County Land Improvement Company (also known as the Fort Collins Agricultural Colony); the Tennessee-Western Colony, at Green City on the Platte River; and the Fountain Colony near Colorado Springs.

Seven ideals (temperance, religion, education, agriculture, irrigation, cooperation, and family values) guided Meeker's selection of colonists and the development of Greeley. Its first residents were a homogenous lot: white, Anglo-Saxon, Protestant, thrifty, conservative, hardworking, law abiding, predominately Republican, and committed to Meeker's vision. Many were Union veterans of the Civil War. They built ditches, reservoirs, fences, farms, ranches, residences, businesses, schools, churches, hotels, and buffalo hide tanning factories. Laws governing the distribution and use of water were created, potatoes became the first commercially viable crop, and large produce companies were established along the railroad.

Four elections in the 1870s pitted Greeley against its neighbor, Evans, in a contest for the Weld County seat. Greeley won this hard-fought battle in the 1877 election, and a three-story brick courthouse was built in 1883. In the 1880s, an electric light company was established, eight artesian wells were dug in the downtown area, and a $65,000 municipal water system was installed. Two opera houses and a system of ward schools were built, and in 1890, construction began at the newly established Colorado State Normal School. With a population of 2,177, Greeley was incorporated as a city of the second class in 1886 and established wards, a city budget, and elected a mayor and aldermen. Over the first 30 years, the colonists survived four locust plagues, a depression and blizzards in the 1870s, the ebullient growth and prosperity of the 1880s, and the Panic of 1893 and subsequent years of depression in the 1890s.

At the dawn of the 20th century, Greeley had 3,023 residents, and its reputation as the "Garden Spot of the West" was further strengthened by a second boom in agriculture. The Greeley Sugar Factory was built in 1902, a potato starch factory in 1906, and a canning company in 1907. Agricultural expansion between 1900 and 1949 (the sugar beet industry and sheep and cattle feeding) brought a succession of new immigrants (Germans from Russia, Japanese, Hispanics from the American Southwest, and Mexican nationals). These hardworking laborers changed the demographics and neighborhoods. Greeley's east side was dubbed "Little Russia" by 1904. Greeley's Spanish Colony was platted in 1924 by the Great Western Sugar Company to entice its elite Spanish-speaking migrant laborers to build adobe homes and become permanent property-owning residents. Sugar beets, nicknamed "white gold," surpassed potatoes as the most important crop by 1920. Visionary citizens and aldermen in 1907 secured "pure mountain water" for the city from the north fork of the Cache la Poudre River at Bellvue via a 38-mile wooden stave transmission line. Water, Greeley's "liquid gold," has always governed the community's ability to change, grow, and prosper during wet and drought cycles.

Greeley was the preeminent town in northeastern Colorado from 1900 to 1950. Daniel A. Camfield, "the Empire Builder," purchased downtown properties, including the Oasis Hotel, which he remodeled, enlarged, and renamed the Camfield. Two new Weld County hospitals were built in 1903–1904. A new city hall, fire station, and library were built north of Lincoln Park in 1907, along with new downtown commercial buildings.

Prosperity continued during the World War I era. With two new ward schools, six new structures at the state normal school, a plethora of clubs and cultural activities, and six new neoclassical buildings (the Sterling Hotel and Theater, Elks Lodge, high school, post office, and Weld County Courthouse), residents proclaimed Greeley was "the Athens of the West."

During the 1920s, downtown streets were paved. The short-lived (12 years) streetcar line was bankrupt by 1922, as automobiles became the preferred mode of travel on Greeley's wide streets. Aviation made its debut in 1928 when the Greeley Municipal Airport opened at Eighth Avenue and Twenty-Fifth Street. Two milestones were achieved in 1929: Greeley's first zoning plan and ordinance, prepared by Saco DeBoer, city planner and landscape architect for the City of Denver, was adopted by the city council, and Nathan Meeker's two-story adobe home, purchased with private and city funds, became Greeley's first museum.

The Colorado State Teachers College (formerly the Colorado State Normal School) was renamed Colorado State College of Education (CSCE) in 1935, and during this decade, nine new structures were built on campus. James A. Michener was a graduate student and sociology teacher

at CSCE from 1936 to 1941, and his knowledge of this area was incorporated into his popular novel *Centennial*, published in 1974, followed by a television miniseries in 1978.

The drought of the 1930s spurred many local citizens, led by *Greeley Tribune* editor Charles Hansen, to find water diversion and storage solutions to sustain northern Colorado's municipal, agricultural, and industrial needs in times of drought and growth. Citizen-driven initiatives helped create the Colorado-Big Thompson Project (C-BT) an ambitious trans-mountain water diversion project. Authorized by the US Congress in 1937 and completed in 1957, the C-BT brings water from Colorado's western slope through a 13.1-mile tunnel to Front Range cities, including Greeley.

Greeley's population was 15,995 in 1940. Commercial and residential construction lagged during World War II with the rationing of materials. In 1943, Greeley Camp 202, a $1.5-million prisoner-of-war facility, opened eight miles west of Greeley and employed both military and civilian workers, and a new airport, Crozier Field, was dedicated in 1944.

Following World War II, Greeley's formula for mid-century success was "Growth + Industry = Jobs." New businesses, industries, residential subdivisions, schools, churches, parks, and shopping centers transformed Greeley's economy and character. Optimism, prosperity, and growth (20,354 residents in 1950) spurred the construction of modern and affordable ranch-style tract homes in the new subdivisions of Arlington, Alles Acres, and Hillside. These appealed to veterans and others anxious to resume civilian life, find jobs, continue their education, and start families. Midcentury milestones included the opening of the new $3.2-million Weld County Public Hospital (1952), Heath Junior High School (1955), and Greeley's first mall, Hillside Center (1957).

Ben Cruce, visionary city manager from 1954 to 1971, realized that rapid growth in the future meant farms lying west of Twenty-Third Avenue would be annexed into Greeley's city limits for nonagricultural uses. With citizen and city council input, Cruce implemented fair and practical solutions for impending growth. A comprehensive zoning plan, not only for the city, but also for land extending three miles outside the city limits, was adopted to ensure uniform construction and safety codes. Building fees were increased so land for new parks could be purchased without using tax funds. Greeley was chartered as a home-rule governmental organization in 1958 and became the first city in the United States to create a department of culture to coordinate the activities of the city's museum, library, recreation, and adult education programs. Citizens, engineers and city council developed long-range improvement plans for the water and sewer system (including 254 units of water from the Northern Colorado Water Conservancy District's C-BT project for future growth), the traffic system, and recreational facilities.

In 1960, Greeley-Capitol Pack, Inc., opened a 92,000-square-foot, $2-million plant. One of the nation's most technologically advanced cattle and lamb slaughtering facilities, it employed 300 people and processed 600 cattle and 240 lambs daily, with weekly volume valued at $1 million. The plant was the largest industrial development in Greeley since the sugar factory opened in 1902.

Greeley's population has grown from 1,000 people in the 1870s to 100,000 people in 2015. Although agriculture and water retain their historical importance, since the 1970s, other services and enterprises, including higher education, health care, technology, the energy sector (oil and gas), and the arts have created a diverse economy and a sustainable and successful city.

One

TEMPERANCE

Before Greeley was established, Horace Greeley called Nathan Meeker and Robert Cameron into his office at the *New York Tribune* and said, "There are many places in the world you can go to and get drunk, but there are very few places that you can go to where you are obliged to keep sober." Greeley advised them to build a temperance town near the Rocky Mountains where industrious, moral, and intelligent people would live by irrigation and prosper in a new climate.

Union Colony property deeds had a reversionary clause that stated, "It is expressly agreed between the parties hereto, that intoxicating liquors shall never be manufactured, sold, nor given away in any public place or resort as a beverage, on said premises; and that in case any of these conditions shall be broken or violated, this conveyance and everything herein contained shall be null and void."

Greeley's sobriety and conservative values were either applauded or scorned. Grace Greenwood, in *New Life in New Lands* (1873), heard this advice from a man on the train from Cheyenne, Wyoming, to Greeley: "Don't stop in Greeley; you'll die of dullness in less than five hours." She observed, "There is not a billiard saloon in the whole camp, nor a drink of whiskey to be had for love or money." In *A Lady's Life in the Rocky Mountains* (1873), Isabella Bird commented, "As the men have no barrooms to sit in . . . Greeley was asleep at an hour when other places were beginning their revelries." With no saloons or billiard halls, Meeker recommended people patronize their own homes or form clubs to meet their educational, social, and civic needs. Clubs quickly became prolific, and parlor skating, baseball, bicycling, croquet, music, and theatrical productions provided entertainment.

After the repeal of national prohibition in 1933, Greeley upheld its temperance principles, but residents quenched their thirst for liquor in adjacent "wet" communities. People joked that Greeley was located between eatin' (Eaton) on the north and drinkin' (Garden City, Rosedale, and Evans) on the south. In 1969, Greeley voters approved the sale of liquor in Greeley by a margin of just 235 votes.

Greeley, Colorado, is named for Horace Greeley, founder and editor of the *New York Tribune*.
Greeley enthusiastically advised people to "go west" if their opportunities in the East were limited.
He championed educational reforms, Fourier's ideas, westward expansion, and the transcontinental
railroad and opposed slavery, liquor, tobacco, prostitution, gambling, and capital punishment.
Greeley's overland journey from New York to San Francisco in 1859 brought him to Denver during
the height of the gold rush. He endorsed Meeker's ideas, was the first treasurer of the Union
Colony, owned property here, and loaned money to Meeker to establish the *Greeley Tribune*.
On October 12, 1870, Horace Greeley addressed the colonists in front of the *Greeley Tribune* on
his only visit to the town named in his honor. He advised them to build more ranches and hire
herders, as he felt they could control livestock better than fences.

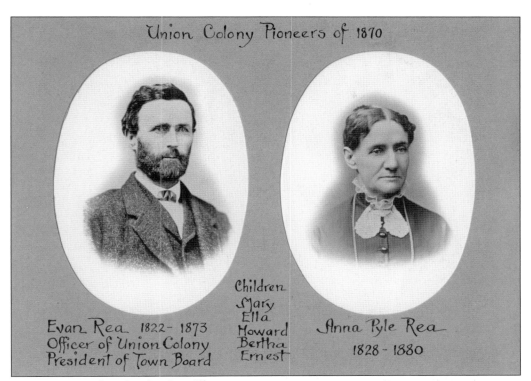

Evan Rea 1822-1873
Officer of Union Colony
President of Town Board

Children
Mary
Ella
Howard
Bertha
Ernest

Anna Pyle Rea
1828-1880

Evan Rea arrived in Greeley from Illinois on May 7, 1870, and his wife, Anna, and children joined him on October 10. Evan, a temperate and talented man, opened a blacksmith shop at 802 Ninth Street, built a house at 903 Tenth Street, and manufactured bricks at the west end of Main (Eighth) Street. Evan was on the executive council of the Union Colony in 1870 and was elected president of the board of trustees in 1871 and 1872. He died of meningitis in 1873.

Anna "Annie" M. Green and her family arrived from Pennsylvania in May 1870. Her impressions of early Greeley, ranging from disgust to delight, were chronicled in her book, *Sixteen Years on the Great American Desert or the Trials and Triumphs of a Frontier Life*. She organized an amateur thespian troupe, the Union Colony Victims Company, and penned poetry about Greeley's temperance principles, successes, and failures.

Mt Carroll Dec 22nd 1869

Mr N. C. Meeker

Dear Sir. I have
read your Proposition to start a
colony in Colorada. and would wish
to join it, My present occupation
is blacksmithing my age is 47
My health is good I have a
wife and 5 children one married
4 at home my I have been a life
long temperance man, and have
been a member of the Methodist
Episcopal church for 28 years
if any referance is wanted I can give it
 I have been to Calafornia in 1850
and was at Pikes peak in 1859
and was much pleased with the
scenery, I was as far south as Pikes
at that time. and fron there went

Page one of Evan Rea's letter to Nathan Meeker reveals he is a family, temperance, and religious man who prospected for gold in California in 1850 and again at Pikes Peak in 1859.

up into the mountains
and came home the next fall,
I was born in eastern Pennsylvania
and have been living in Illinois
for 21 years

I have Property in notes and
real Estate worth perhaps 4000
dollars, could turn 2000 into
money in the course of one
year, I would like to be
Put on your list and hear
more from you

I have been a reader of the
Tribune for 18 years
Yours Truly
Evan Rea

Adress me at Mount Carrole
Ills
P.S. quite a number here
wish to join you

Page two of Evan Rea's letter recounts his good health and character, blacksmithing abilities, pioneering spirit, familiarity with the West, and good financial resources, all useful skills and assets Meeker looked for when he chose only "proper people" as members of the Union Colony.

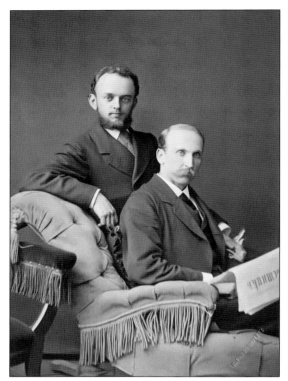

One Sunday in 1870, Gen. Robert A. Cameron led worshipers to a saloon on Greeley's outskirts to convince its owner to surrender his liquor inventory and leave. As the $200 "settlement" was being transacted, a fire, most likely the work of Ralph Meeker (Nathan Meeker's son) and his friends, was discovered inside the saloon. Charges were filed against the perpetrators, but nobody was found guilty in Greeley's "whiskey riots." Ralph Meeker (seated) and Alfred Wheeler were *New York Herald* correspondents during the Russian-Turkish War when this photograph was taken in St. Petersburg in 1877.

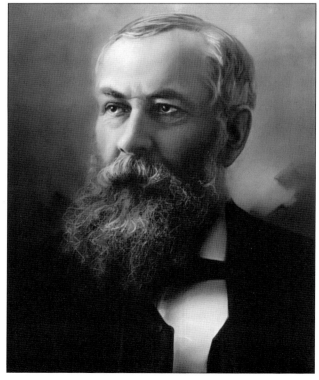

Civil War veteran Gen. Robert A. Cameron's credentials included physician, newspaper publisher, pharmacist, and charismatic promoter of migration to the West. Honoring Horace Greeley's wishes, he inserted a temperance clause into all Union Colony property deeds. Cameron organized and became president and superintendent of the Fort Collins Agricultural Colony in 1872 and recruited prominent Greeley and Weld County residents as officers and trustees. Cameron Pass, a route he discovered through the Medicine Bow Range into North Park, was named in his honor.

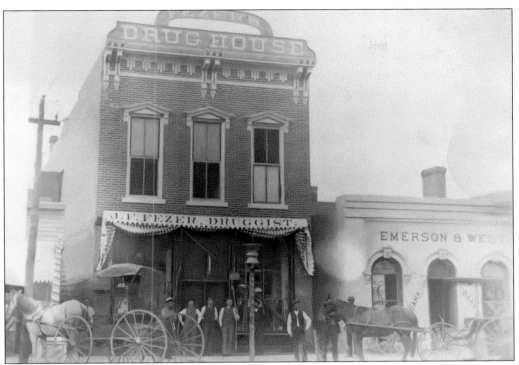

James F. Fezer and Dr. Gulielmus Law arrived in 1870 and opened the Pioneer Drug Store in 1873. In 1876, Fezer bought the building at 815 Eighth Street and added a second story where Dr. Law and Dr. S.K. Thompson (a dentist) had offices. It was difficult for pharmacists to comply with Greeley's temperance mandate, as many medicines contained alcohol. Fezer's Drug House also sold "fancy goods." The Emerson, West, and Buckingham Bank was Greeley's first bank.

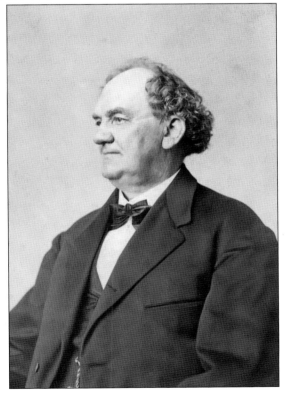

At age 40, Phineas T. Barnum, the "circus king" and "greatest showman on earth," renounced alcohol and became a champion of temperance. His Greeley properties included Barnum Hall and Barnum House, a small hotel that opened in March 1871 on the southeast corner of Sixth Street and Eighth Avenue. On October 12, 1872, he lectured on temperance to a standing-room-only audience at Greeley's Methodist church.

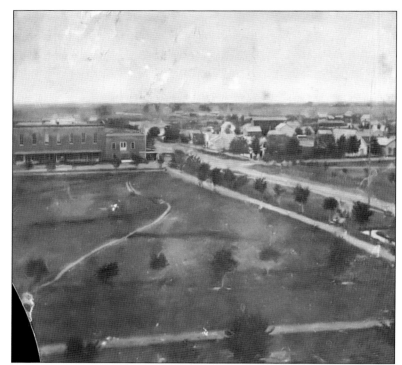

In February 1875, Barnum purchased a two-story building across from Lincoln Park at the northeast corner of Ninth Avenue and Eighth Street from his cousin and agent, E.T. Nichols. Renamed Barnum Hall, merchants occupied the first floor, while the second floor was rented for community events, concerts, theatricals, and roller skating. It was razed in 1884 for the construction of the Park Place building.

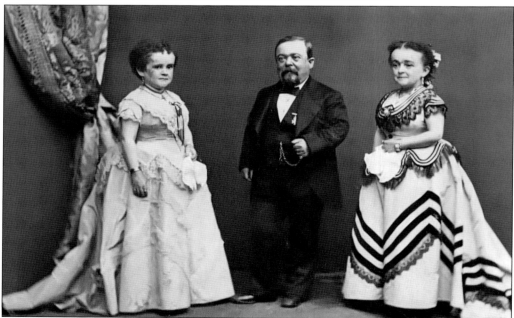

On May 21, 1877, school was cancelled when Barnum's circus troupe of famous midgets arrived in Greeley. Charles Sherwood Stratton, also known as Gen. Tom Thumb (center), his wife, Lavinia (right), and Lavinia's sister Minnie Warren (left) signed autographs and performed matinee and evening shows of songs, dances, and short plays at Barnum Hall. Dressed in military regalia, General Thumb gave his famous impersonation of Napoleon.

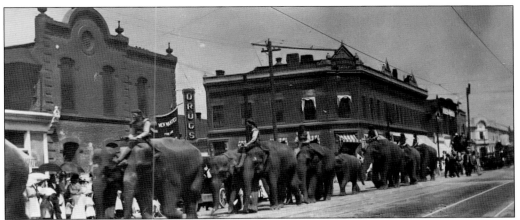

This circus parade is headed south on Eighth Avenue around 1911–1915. The Clark and Faulkner Drug Store and the Union National Bank are at the intersection of Eighth Avenue and Eighth Street. The "circus lot" was east of the railroad tracks near Thirteenth Street. Barnum's circus performed here in 1882, and 8,000 people enjoyed a matinee performance of *Buffalo Bill's Wild West Show* on August 8, 1902.

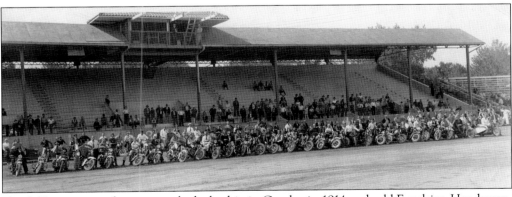

Floyd Clymer opened a motorcycle dealership in Greeley in 1914 and sold Excelsior, Henderson, and Cleveland motorcycles. He organized the first motorcycle races at Island Grove Park and later became a famous racer and promoter of motorcycle and automobile races. This c. 1925–1935 photograph shows racers in front of the grandstand, built in 1925 and paid for by revenue bonds and a 25¢ seat tax.

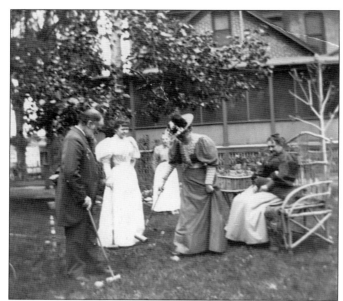

Dr. Jesses Hawes and his family play croquet at their home at 728 Ninth Street. The *Greeley Tribune* reported that it was the favorite game of Greeley people, but that it was a "frightfully moral game and would be nicer if it were naughtier."

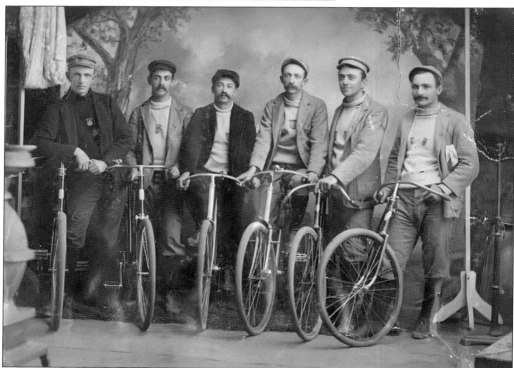

The Greeley Bicycle Club was organized in June 1882 with Henry B. Jackson, president; John C. Mosher, secretary and treasurer; F. Hart, captain; and Will Heaton, scout. The Colonial Wheel Club (for men) and the Atalanta Cycling Club (for women) were organized in 1893. Captivated by this new mode of transportation, exercise, and sport, members enjoyed long-distance excursions and races on unpaved roads. This c. 1890–1910 image of unidentified Greeley cyclists is from Jack Mosher's album.

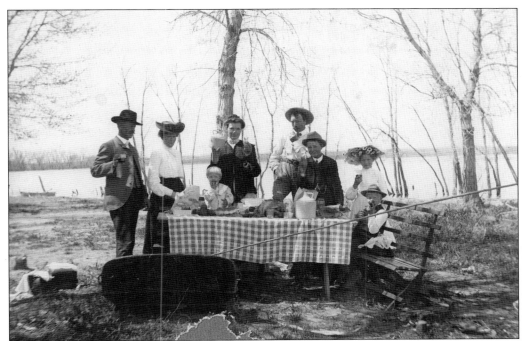

The Charles H. Young and Carl Carlson families picnic at Seeley Lake around 1905–1906. Joseph Seeley, a farmer, realized the lake's recreational value and in 1894 built a dance hall and docks for swimming, boating, and fishing. The Northern Colorado Bathing Beauties Contest was held here in the 1920s and 1930s. An accidental fire after a party on June 26, 1939, destroyed the dance hall, the manager's residence, four outhouses, large trees, and the concession stand. The Ogilvy Irrigating and Land Company, owners of the lake and resort, decided not to rebuild.

Arthur A. Peralta (center) was the superintendent of the Great Western Sugar Factory in Greeley and the sponsor of this baseball team around 1905. Baseball was extremely popular in Greeley. Peralta also coached the Greeley Reds.

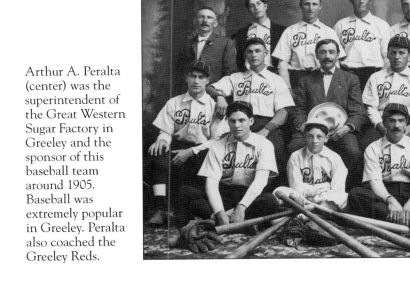

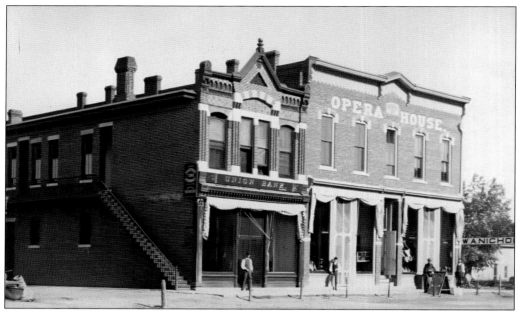

Henry B. Jackson's new $16,000 building at 707 Eighth Avenue had a 400-seat second-floor rental hall with a stage and dressing rooms that could accommodate the needs of national touring companies. Renowned violinist Edouard Remenyi performed at the Jackson Opera House when it opened on August 28, 1883.

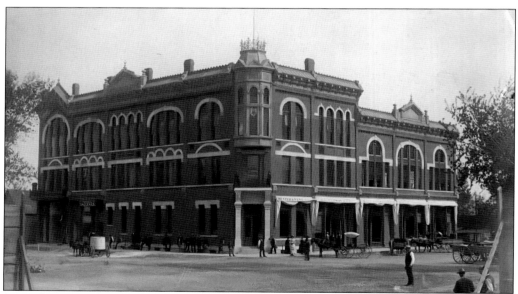

Samuel D. Hunter's 1886 brick building at the southeast corner of Eighth Street and Eighth Avenue was electrified throughout and had a modern steam heating plant and two performance halls. The third floor (facing Eighth Street) was first rented as a drill room and armory, while the second floor (facing Eighth Avenue) was the 700-seat Greeley Opera House, with a 36-by-66-foot stage (northern Colorado's largest) with footlights and a "safe entrance" for women.

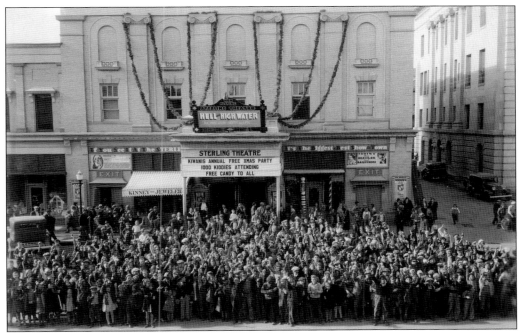

The Kiwanis Club of Greeley, founded in 1922, sponsored a free Christmas party and movies for children in 1954 at the Sterling Theater, 925 Ninth Avenue.

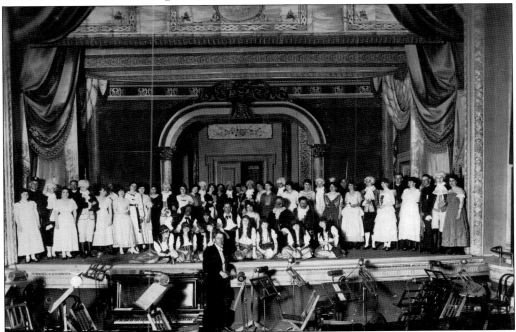

The interior of the 1,200-seat Sterling Theater had one of the deepest stages in the Rocky Mountain region and was a popular venue for touring companies. Its grand opening on May 25, 1911, featured local performers. The Colorado State College of Education presented *The Bohemian Girl* as part of its May Music Festival, seen in this May 2, 1917, cast photograph.

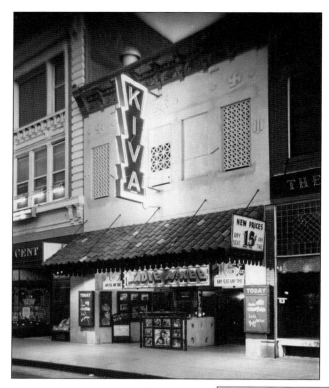

The Kiva Theater at 806 Eighth Street opened around 1932 in a building that once housed the Goodman-Neill Clothing Company (1908–1928) and the D.R. McArthur Hardware Company (1892–1906). Mexican-themed murals were painted on the theater's walls by its manager, Walter Jancke, when it was remodeled in 1945. The theater closed in March 1953.

The Park Theater, 817 Ninth Street, occupied a building constructed in 1918 by Ira I. Sides. Like the Kiva, this was a small "second-run" movie theater that opened around 1922 and closed in December 1952. Across the nation, many small theaters closed in the 1950s as the revenue they produced was not enough to offset rising operating costs.

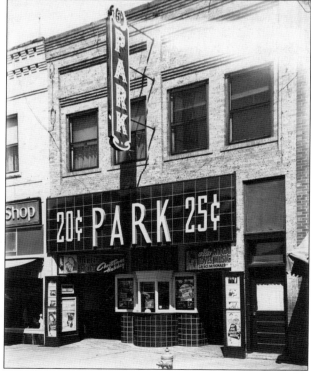

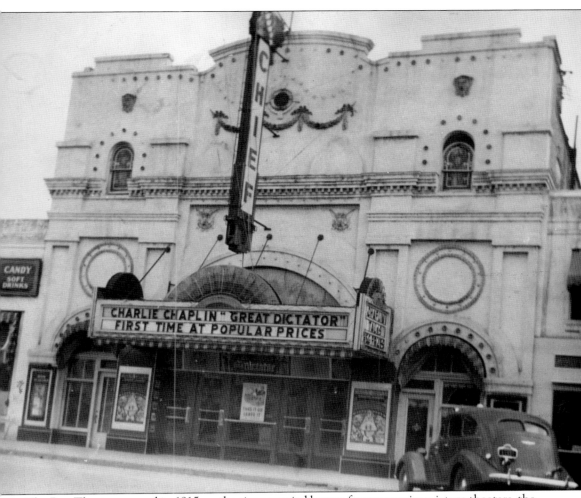

The Rex Theater opened in 1915 on the site occupied by two former moving picture theaters, the Electric (1908–1909) and the Orpheum (1910–1915). The Rex closed briefly in 1934 for remodeling and reopened a few weeks later as the Chief Theater. *The Great Dictator*, a 1940 Charlie Chaplin movie nominated for several Academy Awards, condemned Hitler, the Nazis, Mussolini, Fascism, and anti-Semitism. Reportedly haunted by a woman wearing a long dress, the theater closed in February 1973 and was razed in February 1984.

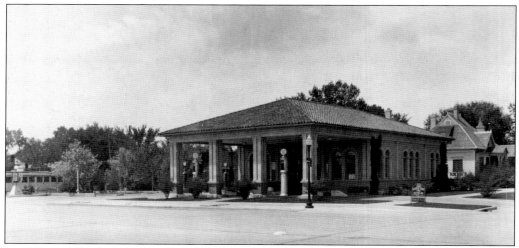

In 1921, C.S. Buchannan's modern filling station at the southwest corner of Eighth Avenue and Fifth Street had large walk-through tunnels fitted with a furnace and duct work for heating his filling station, repair shop, and home. This safety feature eliminated the danger of explosion and fire. Stories persist of liquor being cached in tunnels and ducts under some downtown buildings during Prohibition.

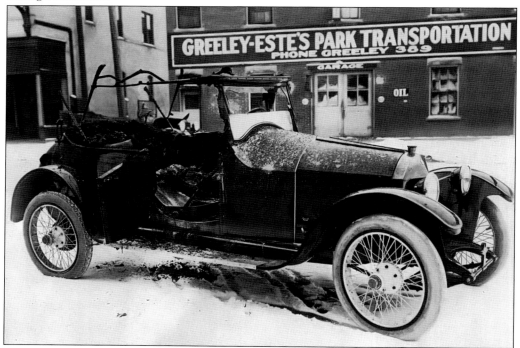

On January 23, 1917, a Cheyenne-Denver Transportation Company truck with a lit oil stove in the back drove inside the Scripps–Van Sickle Garage and exploded. The truck and cargo—many cases of whiskey, two barrels of bottled beer, wine, and other alcohol—along with the garage and 39 cars were destroyed. Greeley enacted an ordinance that banned taking lit oil stoves into a garage. Drivers transporting illegal liquor had to park their vehicles on the street and guard their cargo to keep it from disappearing if they stopped for food, fuel, or repairs.

Members of the Women's Christian Temperance Union (WCTU) pose for a c. 1920s photograph at the First Presbyterian Church. The WCTU advocated for temperance, labor laws, prison reform, and universal suffrage. Prohibition became its main focus after 1900. In November 1911, police chief Dave Camp and Mayor William Mayher hosted a "destruction party" and watched as the WCTU dumped 500 gallons of liquor into the sewer drain in front of city hall.

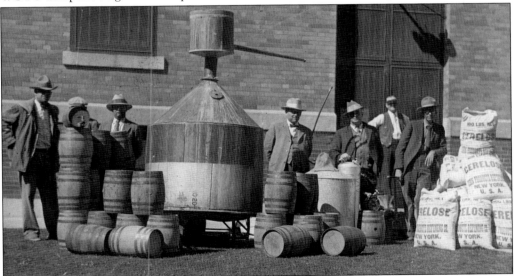

The Weld County Sheriff's Department confiscated brewing and distilling equipment, supplies, and liquor during Prohibition (1920–1933). This image of a confiscated still and bags of cerelose, a fermentable type of dextrose, was taken during Sheriff Ben Robinson's two terms, 1927–1930. From left to right are Bud Wyatt, unidentified (only his hat is visible), Broady Hunter, Ben Robinson, Warren Vose, Hoge Fraser (deputy), and Bert Huffsmith.

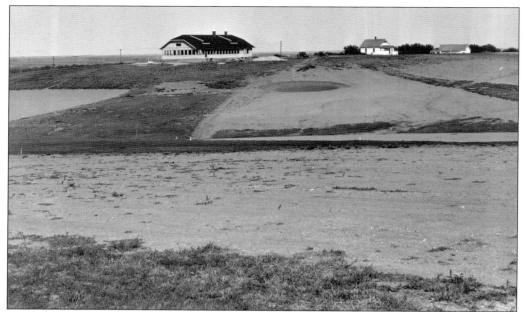

In 1920, H.D. Parker, C.T. Ahlstrand, and W.C. Roberts purchased the 95-acre Hilltop Ranch west of Greeley from Dr. Z.X. Snyder, Victor Keyes, and Samuel Hadden for the new Greeley Country Club (GCC). The course, designed by famous golf pros Tom Bendelow and Willie Dunn, opened in August. The clubhouse, seen here, opened in 1923. In 1935, the city leased the property from the GCC for a municipal course, making it eligible for improvements via Works Progress Administration funding during the Depression. Unable to purchase the property, the city returned it to the GCC in 1938. As a private club, the GCC reimbursed the federal government $2,556 owed for the Works Progress Administration (WPA) improvements to the clubhouse.

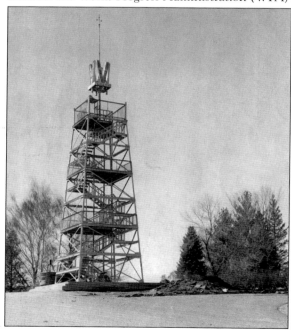

In 1926, First National Bank president John M.B. Petrikin installed a steel observation tower in the middle of the block on Twentieth Street between Tenth and Eleventh Avenues, north of his home on Inspiration Point. Nicknamed "Perspiration Point," the tower and park quickly became Greeley's romantic "hot spot" for couples on "automobile dates." In 1942, Herdman Electric Company installed the neon "V for victory" sign. The tower was removed in May 1965 for the construction of the Student Center at Colorado State College.

In 1948, R.W. Meyer built the Greeley Drive-In Theater, seen in this 1981 photograph, on the north side of West Tenth Street opposite the Greeley Country Club. His son-in-law, Emmett W. Savard, added a new 105-foot Cinemascope screen (touted as Colorado's largest), chuckwagon, projection machine, and sound system in 1956. "Cactus Jack" Redus, a popular host of a Country-Western show on KFKA radio, became the manager. The drive-in was razed in December 1982.

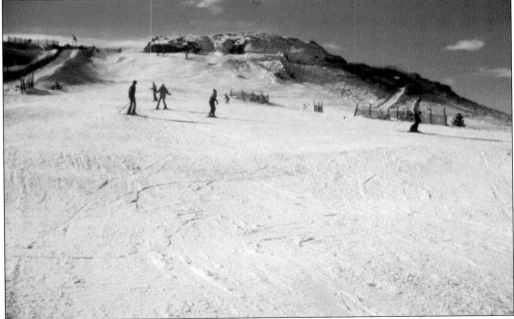

Richard Perchlik and Clyde Davis opened "the world's smallest ski area" eight miles west of Greeley. Sharktooth, Colorado's second ski area to install snowmaking equipment, operated from 1971 to 1985. Boasting "affordable snow" (a one-day adult pass cost $3.50), it had three tubing runs, an ice-skating rink, a 400-foot-wide north-facing slope with a 1,000-foot drop, a Swiss rope tow, and professional ski instructors. Sharktooth once closed when skiers were assaulted by tumbleweeds and topsoil blowing onto the slope from adjacent fields. (Courtesy Ulli Limpitlaw.)

Keep Greeley Great, Selected As Name for 'Dry' Committee

"Keep Greeley Great" is the name adopted this week by a committee formulated last week to promote the retaining of present liquor laws.

"As the name implies, Greeley has something worth keeping," Rev. Edmund E. Train, a spokesman for the committee said.

"It is the consensus of the committee that Greeley is an ideal community in which to live and rear a family. The freedom of the individual is respected in that no one is prevented from using liquor in his own home if he so desires.

"However, there are sufficient restrictions in the present law to protect the citizen. The problems that are invited by public sale of liquor within the town are believed to be greater than the supposed advantages of liquor sales in the downtown area," Train said.

Train indicated the committee is grateful to the response of many townspeople since the committee was initiated a week ago. Among those listed by Train included Mr. and Mrs. Alejandro Gillespie, J. L. Carpenter, John Henderson, Mary Jo Dempsey, George Dvirnak, Phylabe Houston, Raymond Hemphill, Robert Houston, Malcolm McGuire, Al Busby, Aaron F. Jaeger, Lowell Howard and Richard Grenz.

The committee is urging all those who subscribe to its basic position to go to the polls Nov 4 and vote "no" on the referendum to repeal Greeley's present liquor law.

The committee is also inviting persons in sympathy with this view to contact committee members. Contributions, to be sent to Miss Hazel Johnson 1303 9th Ave., secretary-treasurer, will be gratefully accepted.

The initial steering committee is composed of Floyd Otis, Ralph E. Waldo Jr., Miss Johnson. Train and William H. Southard

In 1969, two committees mobilized their forces to support or oppose a November 4 ballot issue to allow liquor sales in Greeley. The Keep Greeley Great Committee opposed allowing liquor sales within in the city limits, while the Watch Greeley Grow Committee favored it. When the 8,202 votes were tallied, liquor won by a margin of 235 votes, ending temperance in Greeley. Dancing in beer halls, however, was not permitted until 1971.

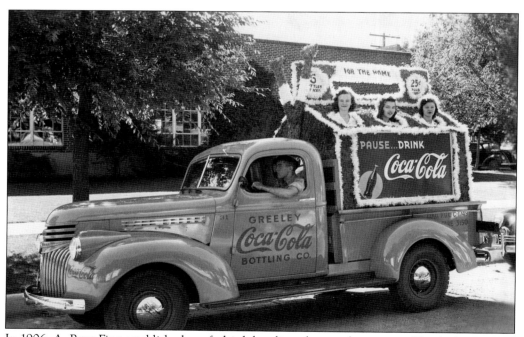

In 1906, A. Bent Fine established a soft-drink bottling plant at the corner of Sixth Avenue and Tenth Street. It operated at two other locations prior to the construction of this building at 1200 Seventh Avenue. Bent's son Albert and grandson Donald also worked at the business. The company's July 4, 1942, parade float acknowledged the efforts of the Allies fighting in World War II, with a V for victory.

Two

RELIGION

Nathan Meeker's ideas for a communal bakery, a laundry, and a community church in Greeley never came to fruition. Colonists' heated disagreements about the qualifications and selection of a minister scuttled the idea of a single nondenominational church. In 1870, five Protestant churches—Baptist, Congregational, Episcopal, Methodist, and Presbyterian—were organized. The Union Colony reserved free lots for any denomination that wanted to build a church. The *Greeley Tribune* reported that the Sabbath in Greeley was almost "universally observed." Temperance, tenaciousness, and patience brought success to individual and civic endeavors, and the colonists tolerated outsiders' taunts that Greeley was the "City of Saints," "Saints' Rest," or the "City of Hayseed and High Morals." Churches and newspapers kept citizens "on the wagon." For example, in 1882, a minister informed his congregation that young ladies had served alcohol to gentleman callers at a New Year's Day open house. The *Greeley Sun* admonished this custom: "Of all the places in the world, Greeley should be the last to set the example of social wine drinking."

In 1884, a small Catholic chapel was built in Greeley. From the 1880s to the 1930s, Scandinavians, Germans from Russia, Japanese, and Hispanic immigrants constructed churches and conducted religious services in their native languages.

In an unusual partnership from 1910 to 1921, the Colorado State Normal School and the Greeley Ministerial Association produced a nationally recognized Bible study course, offered for credit and called the Greeley Plan of Religious and Moral Instruction in State Institutions. An Episcopal seminary, the College of St. John the Evangelist, operated from 1910 to 1936.

By 1949, Greeley, with a population of 20,354, had 37 churches. Today, there are more than 100 churches and worship centers.

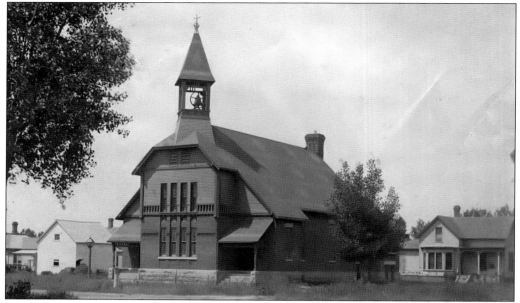

The First (Park) Congregational Church was established in Greeley in 1870, and services were conducted in the former adobe-brick Park Hotel from 1872 to 1881. The second church, seen here, designed by T.W. Silloway of Boston, Massachusetts, was constructed between 1880 and 1883 at the southwest corner of Tenth Avenue and Eighth Street.

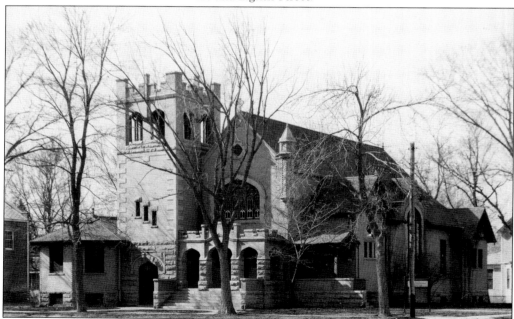

The sanctuary and other features of the 1883 First (Park) Congregational Church were preserved and incorporated into a larger English Tudor–style church designed by Denver architect T. Robert Wieger and built in 1907 for $24,000. The building became the home of the First Covenant Church from 1955 to 1984. The Congregationalists built a new church at 2101 Sixteenth Street in 1956.

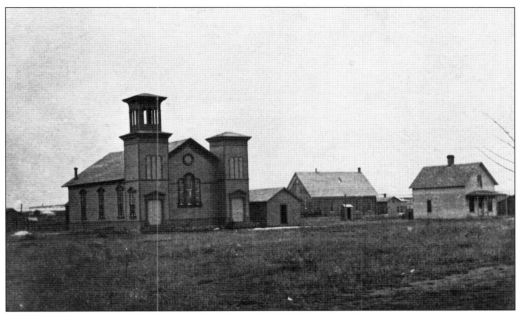

In 1871, the Baptists received a $500 prize from the Denver Pacific Railroad for building Greeley's first church on Ninth Street opposite Lincoln Park. Following the Baptists' lead, a few months later, the Methodists occupied their new $3,500 brick church at the northwest corner of Tenth Street and Tenth Avenue, seen in the background of this c. 1875 photograph.

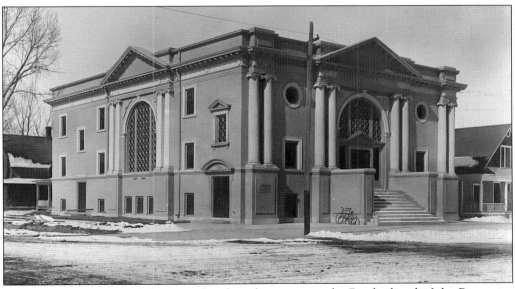

In 1909, the Baptists sold the 1871 church and property to the Brotherhood of the Protective Order of the Elks, and in 1911, it was moved to Island Grove Park for an exhibition building. The second church, seen here, was designed in the Classical Revival style by architect R. Robert Wieger and dedicated in 1911. Baptist pastor DeWitt D. Forward proposed the Greeley Bible Plan. This church is listed in the National Register of Historic Places.

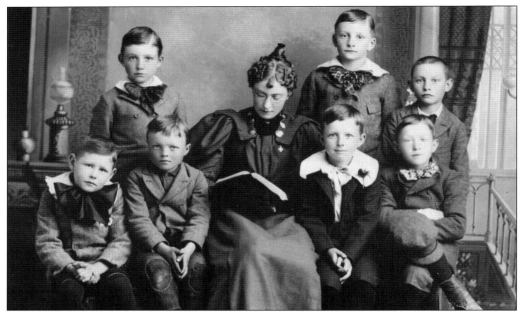

Sunday schools provided religious education and wholesome social opportunities for youth. Effie Frazier taught these boys in her Baptist Sunday school class. From left to right are (first row) Lloyd Bridges, Fred Dubach, Effie Frazier, Earl Chappelow, and Theodore Glazier; (second row) Arthur C. Deffke, Frank L. Deffke, and Fred Rosling. Proper attire was expected, although one lad's breeches have large holes in both knees.

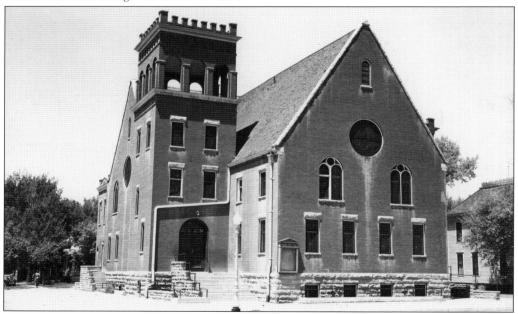

Thirty-five members of the Methodist Episcopal church held their first service at James Scott's home on May 15, 1870. Their 1871 church was razed in 1906 to construct a new church, seen here. This second church was razed in May 1962, along with the parsonage and custodian's house, for the construction of a third church at 917 Tenth Avenue, which was dedicated in September 1963.

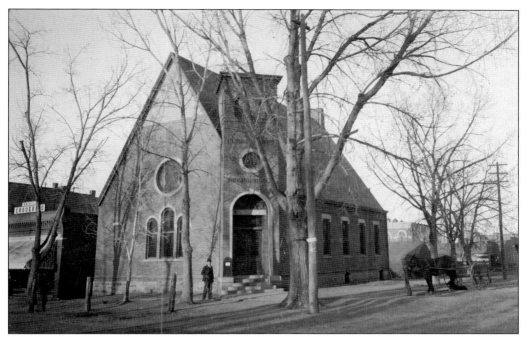

Unitarians and Universalists had informally met since 1874, but in 1880, they organized the First Unitarian Society of Greeley. With $4,000 in pledges, they built Unity Church in 1886–1887 at the northeast corner of Ninth Street and Ninth Avenue. At the request of the board of education, the Unitarians rented the church to the school district for Edith Knapp's ninth-grade class in 1887–1888 because of overcrowded conditions at the Meeker School.

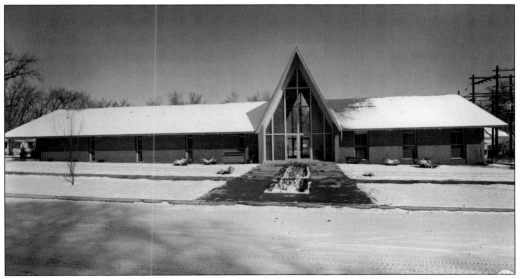

The Christian Scientists organized in 1902 and incorporated as the First Church of Christ, Scientist, Greeley, in 1912. A church was built in 1917–1918 at the northwest corner of Fourteenth Street and Eighth Avenue. It was sold, and a new church, seen here, was built in 1957 at Fifteenth Avenue and Tenth Street. The church's public reading room was located in the Greeley Building from 1919–1955.

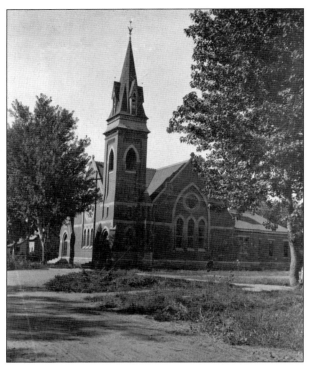

Presbyterians organized in Evans, Colorado, in 1871 but organized a new congregation when they moved to Greeley in 1884. Denver architect H.B. Seeley designed the $12,500 United Presbyterian Church of Greeley, seen here at the northwest corner of Eleventh Avenue and Eighth Street. Constructed of pressed brick and white freestone from Boulder, it was built in 1891–1892 and razed in June 1963.

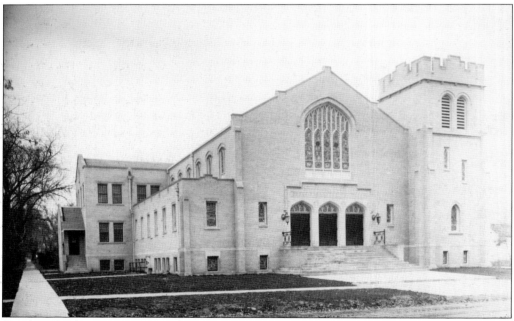

Greeley's Presbyterians organized in August 1870 and outgrew two small churches, one built in 1872 and the other in 1889. The Tudor-style church seen here was constructed in 1919–1920 for $80,000 at Ninth Avenue and Fourteenth Street. It had a massive sanctuary and 30 rooms. In 1961, the United Presbyterian Church and the First Presbyterian Church merged as the First United Presbyterian Church of Greeley.

By 1908, Catholics, a minority in Greeley, had outgrown the 1884 chapel at 1125 Sixth Street and an 1899 church at the northwest corner of Ninth Avenue and Tenth Street. A new Gothic-style church, designed by Greeley architects Ward and Patterson, was constructed in 1908–1909 for $30,000 at 915 Twelfth Street.

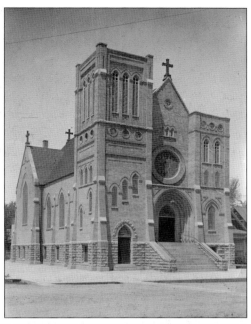

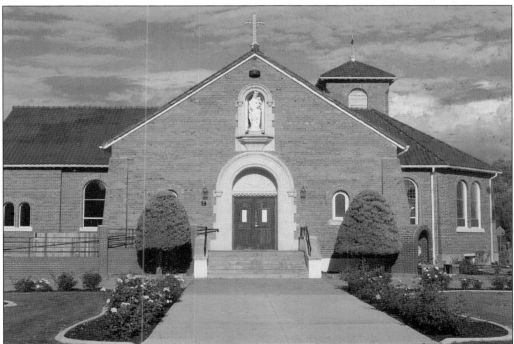

Hispanic parishioners at St. Peter's had lobbied the diocese to build a church for Greeley's Spanish-speaking Catholics. In 1941, a city block in north Greeley was purchased for $3,500, but construction was delayed until 1947 because of World War II. Designed by Denver architect John K. Monroe in a California Mission style, it cost $84,000. It was dedicated in 1948 and named Our Lady of Peace Catholic Church in honor of soldiers and parish members who died during World War II.

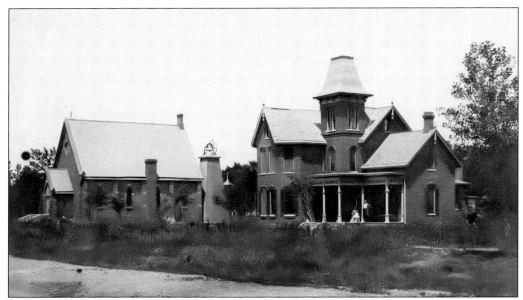

An Episcopal church was built in 1875 at Eleventh Street between Eighth and Ninth Avenues on lots donated by Benjamin H. Eaton. It served the congregation until 1910. Notice the freestanding bell tower and the 1881 rectory, a gift to the church from Samuel D. Hunter.

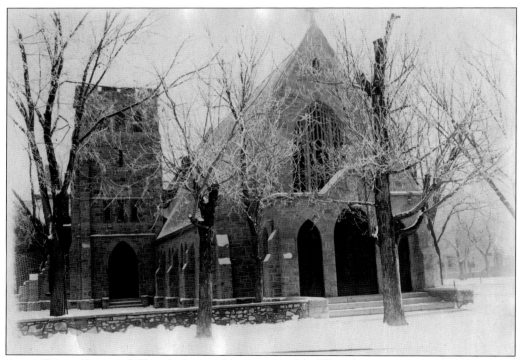

A new Trinity Episcopal Church, designed by architect J.A. Weitzel, was constructed 1910–1913 at the northeast corner of Ninth Avenue and Eleventh Street. The exterior was of Indiana sandstone and the interior of red brick, and it served the congregation until 1963.

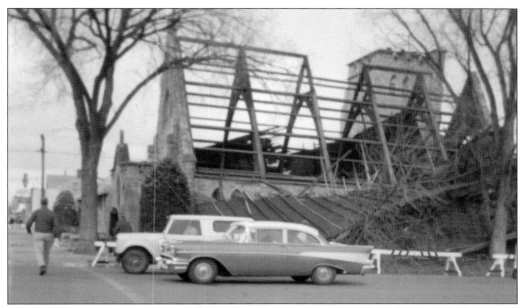

On Monday, March 11, 1963, at 9:35 p.m., the furnace exploded at Trinity Episcopal Church and destroyed the sanctuary, its furnishings, a pipe organ, and beautiful stained-glass windows. The congregation purchased land west of Thirty-Fifth Avenue, and a new $400,000 church was built at 3800 West Twentieth Street and dedicated in 1967.

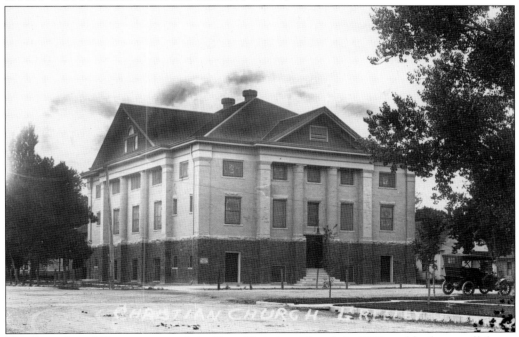

The Disciples of Christ organized the First Christian Church in 1902 and built a small frame tabernacle at Eighth Avenue and Thirteenth Street that was torn down to construct this church in 1909–1910. With the mortgage almost retired, a fire on December 31, 1922, destroyed the interior, which was rebuilt the following year.

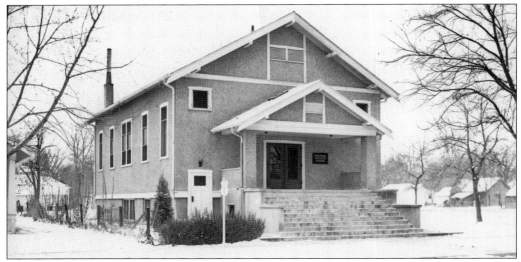

Seventh Day Adventists held camp meetings in the 1880s and organized a Sabbath school and church in George William's home in 1893. In 1902, services were held in a frame building at Fourteenth Avenue and Eighth Street. In 1926, a new brick-and-stucco church, seen here, was built at 1228 Ninth Street. Two other churches joined this congregation in 1943 and 1946. Beth Israel congregation purchased the building in 1953 when the Adventists moved into their new church at 1002 Twenty-First Avenue.

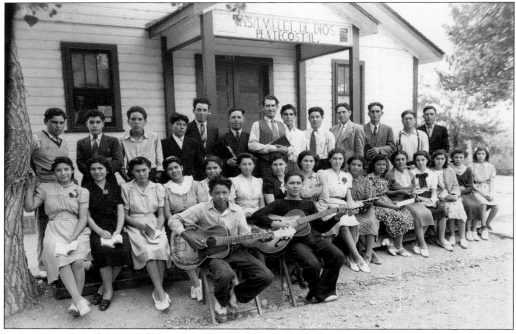

In January 1930, the second church at Greeley's Spanish Colony, Assamblea de Dios (Pentecostal Assembly of God), was dedicated. Colony residents contributed to the building fund started by the Women's Mission Society, which raised money from the sale of a handmade quilt and other items. The 26-foot-by-40-foot church cost under $1,000 and was built by the men at the colony when the sugar beet harvest ended.

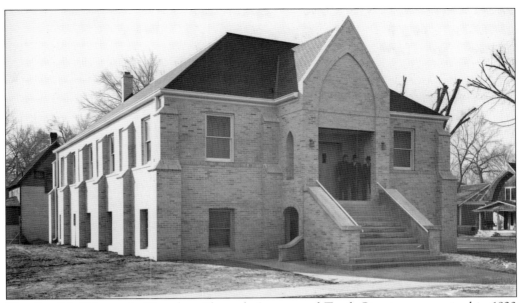

The Swedish Tabernacle Church at Eleventh Avenue and Tenth Street was organized in 1923 with 18 members. Its basement was built in 1924, the sanctuary completed in 1937, and its name was changed to the First Covenant Church in 1938. Other Swedish churches in Greeley included the Swedish Evangelical Free Church, the Swedish Evangelical Lutheran Immanuel Church, and the Swedish Baptist Church.

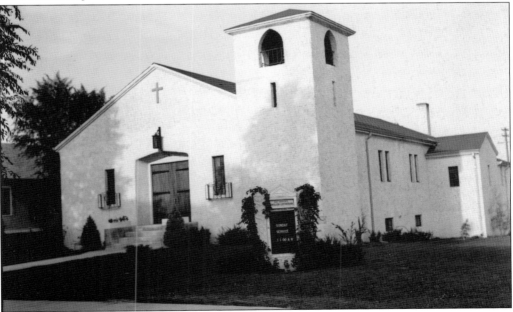

Our Savior's English Lutheran Church began in 1927, when several families invited Rev. Walter Fleischman of Eaton to conduct services in Greeley for them. In 1928, a small chapel for 90 people was built at the northeast corner of Eighth Avenue and Twenty-First Street. By 1936, a larger building was needed, and a Spanish-style sanctuary was built. It was used until a new church was built in 1957–1958 at 1800 Twenty-First Avenue.

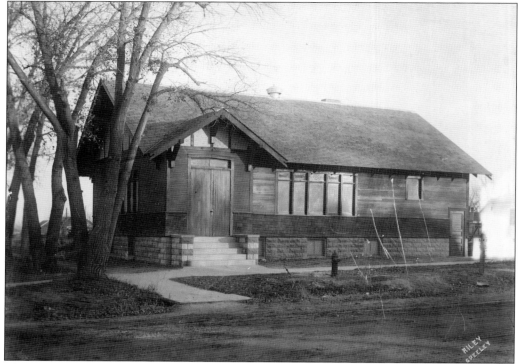

The Swedish Baptist Church was organized in 1901, and in 1914, this church was built at the corner of Eighth Avenue and Sixteenth Street. By the 1920s, services were conducted in English rather than Swedish, and it was renamed Bethel Baptist Church of Greeley in 1931. A new $87,500 church was built at 2307 Seventeenth Avenue in 1960.

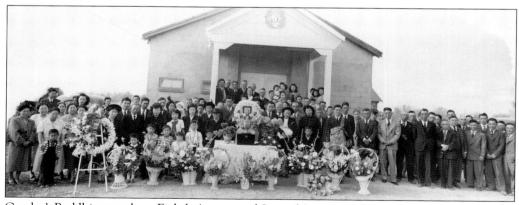

Greeley's Buddhist temple, at Eighth Avenue and Second Street, was built around 1937 by members of the Japanese community, which came to Weld County starting in 1904 to work in the sugar beet fields. Relatives and friends gathered at the temple for the memorial services of Pfc. George S. Sameshima of Company G, 442nd Infantry, who died in action on July 6, 1944, in the Rome-to-Arno campaign. His remains were interred at Linn Grove Cemetery on April 20, 1957.

Three

EDUCATION

Nathan Meeker's article "A Western Colony" stated that one of the first institutions in a new town, "should be a first-class school, in which not only the common, but the higher branches should be taught, including music." Town lots were sold and larger parcels of land outside the original city limits were auctioned to fund the construction of a school and other civic buildings. In 1873, the Greeley Public School was built for first through 12th grades and became, as Meeker hoped, "the pride and ornament of the place." Rev. Oscar L. Fisher opened Greeley's first free night school in the winter of 1875 and taught bookkeeping, penmanship, commercial arithmetic, reading, and writing to 60 men and women.

Neighborhood ward schools were built in the 1880s as the town grew. They were Washington (North Ward), Lincoln (East Ward), and Horace Mann (South Ward). Later, the Franklin and Gipson Schools served students in west Greeley and the Spanish Colony. A high school was built west of the Greeley Public School (also known as the Meeker School) in 1895, and in 1902, a new grade school adjoined it. A new high school (later a junior high) opened in 1912 and inspired students with bold inscriptions on either side of the entrance: "The High School Perpetuates the Principles of Our Pioneers—Justice, Virtue, Liberty, Temperance and Education," and "If You Covet Learning's Prize, Climb Her Heights and Take It. In Ourselves Our Fortunes Lie, Life Is What You Make It."

Greeley residents wanted to recruit and retain highly skilled teachers and lobbied aggressively for a teachers' training school, and the Colorado State Normal School was approved by the state legislature in 1889. Its first building, Cranford Hall, was constructed between 1890 and 1903. Several name changes followed: Colorado State Teacher's College (1911); Colorado State College of Education (1935); Colorado State College (1957); and University of Northern Colorado (1970).

New ward schools were built in the 1910s, followed by Cameron Elementary in 1919, Greeley (Central) High School in 1927, and Arlington Elementary in 1941. Greeley Junior High, a Public Works Administration project, was built in 1937. Six modern public schools were built in the 1960s, and Aims Community College was established in 1967.

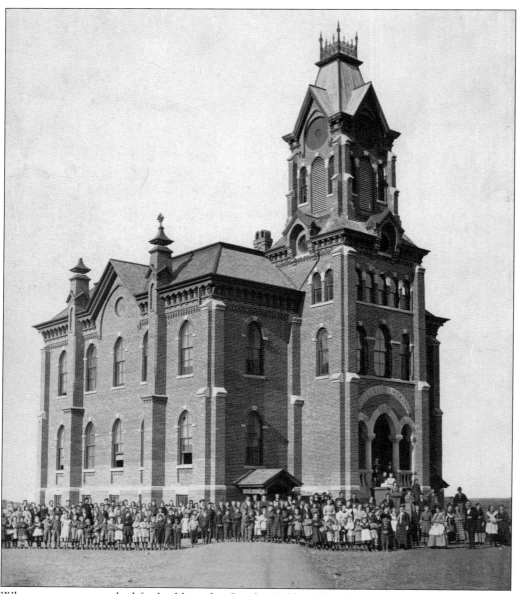

When money earmarked for building the Greeley Public School was "appropriated" to enlarge the Number Two Ditch, $15,000 in school bonds were issued in 1872 to complete the $30,000 building, located on Tenth Avenue west of Lincoln Park. It opened in 1873 for all 12 grades, and its first graduating class in 1880 had five students. Also called the Meeker School, it was deemed unsafe and razed in July 1922.

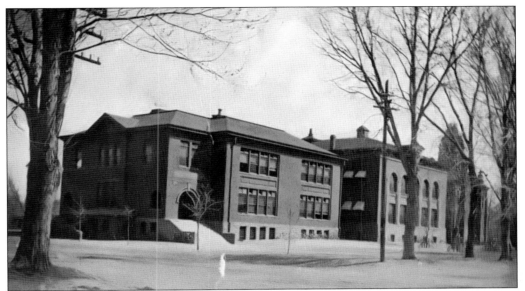

The 1895 Greeley High School (center) was built during the depression of the 1890s to relieve overcrowding in the Meeker School. Designed by Denver architect Harlan Thomas at a cost of $28,000, it had superior heating, plumbing, and ventilation systems, eight classrooms, cloakrooms, bathrooms, and a basement for a gym. The 1902 grade school (left) added another 12 classrooms.

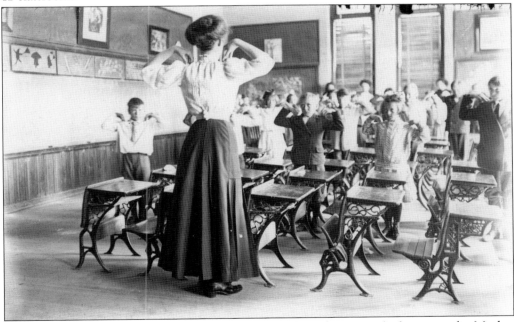

Building sound minds in strong bodies, a teacher leads students in calisthenics at the Meeker School in the 1890s. When it opened in 1873, this school had "warm quarters, plenty of light, and everything in complete order" plus a "library, laboratory and chemical and philosophical apparatus." According to the *Greeley Tribune*, its well-paid teachers were proficient in all the branches of learning and New England discipline.

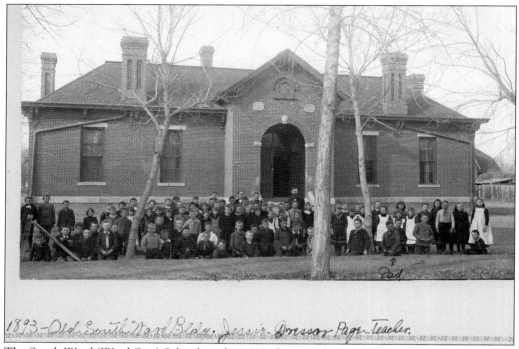

1893-Old South Ward Bldg. Jessie Dresser Page Teacher.

The South Ward (Ward One) School, in this 1893 photograph, was designed by Greeley architect William G. Bentley in 1882 and built at the northeast corner of Eleventh Avenue and Twelfth Street by contractors William Houghton and William McElroy. Jessie Dresser Page, an 1880 graduate of the Meeker School, and a Miss Stanley were its first teachers.

Between 1913 and 1917, crowded, outdated schools in the East, North, and West Wards were replaced with new brick Mission Revival–style buildings. Many German-Russian and Japanese children attended this 1915 East Ward School at 1025 Fifth Avenue, known also as Lincoln School. Immigrants attended evening Americanization classes held here for 8 to 12 weeks annually starting in 1920. The Greeley Woman's Club helped recruit teachers who earned extra money teaching civics, reading, and writing to prospective citizens.

Application and Permit to be Absent From School

GROUNDS.

1. (✓) That the child's help is necessary for its own or its parents' support.
2. () That the child has been duly certified by a reputable physician to be physically or mentally unable to perform school duties.
3. () That the child shall receive adequate instruction as provided by law during the time of such absence, from a qualified teacher in the home, or in a private school.
4. () That the superintendent be satisfied that some other condition exists under which it is for the best interest of the child to be excused from school duties during the time of such permit.

I, *Conrad Borgens*,hereby make application to the superintendent of School District No. *8* .., to permit *Frederick Borgens* to remain out of school from *Thursday*, the *4* day of *April*, 19*18*. to *Friday*., the *17* day of*May*, 19*18*. inclusive, for the of the grounds stated above, and hereby certify that the grounds upon which this permit is asked actually exist, and that I will promptly return said pupil to school at the expiration of the permit, or as soon as the grounds upon which it is granted cease to exist prior to its expiration.

Dated at *Greeley* Weld County, Colorado, this *4th*. day of *April*, 19*18*.

Conrad Borgens
(*Parent or Guardian)

† Upon the grounds checked above, permission is hereby given said child to be absent from school beginning the *4th* day of *April*, 19*18*, and ending not later than the *17* ... day of *May*, 19*18*.

H. E. Brown
Superintendent School District No. *6*

This permit applies only to District No., Weld County, Colorado, and is revocable at any time prior to its termination if in the opinion of the Superintendent it was not obtained in good faith or if the reasons for issuing it no longer exist. It must be preserved and shown on demand of any police officer or school official. Loss of permit automatically cancels it and a copy must be obtained or the child returned to school.

† For good and sufficient reasons to the Superintendent appearing, said application is hereby denied.

* Erase accord to fact.

..
Superintendent School District No. ____

An "Application and Permit to be Absent From School" was required when children were legitimately excused at a parent's request to assist with planting in the spring or harvest in the fall. Many German-Russian and other children worked long hours in area sugar beet fields. Conrad Borgens was a student at the East Ward School. (Courtesy Sandra Scott.)

Cameron Elementary School was built in 1919–1920 at 1424 Thirteenth Avenue and named for Robert A. Cameron, an influential Greeley pioneer. Four classrooms were added to the building in 1936, along with a gymnasium in 1952. The school was remodeled in 1984, and four classrooms and a courtyard were added in 1996. The school was the longest operating elementary school in District Six when it closed in 2010.

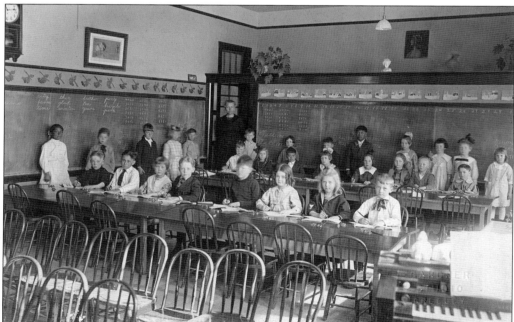

Edith Heath, seen here, was the first-grade teacher and principal at Cameron from 1920 until her retirement in 1940 after 43 years of teaching. She was an exceptional educator and dog trainer, and Jackie, her fox terrier, frequently performed for the children in her classes. Heath died in 1952, and a new junior high school, built in 1954–1955, was named for her.

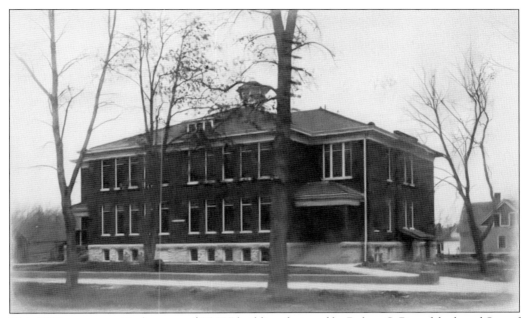

This 1906 two-story, 10-classroom, $35,307 building designed by Robert S. Roeschlaub and Son of Denver replaced the two-room South Ward School. In 1931, its principal, Luna Smith, renamed it in honor of the famous educator Horace Mann. It closed in 1941, but in September 1943, it housed 150 Italian prisoners of war. Their boisterous singing of classic Italian songs was heard throughout the neighborhood. The building was sold for salvage and razed in 1954 to construct a new $500,000 Safeway grocery store.

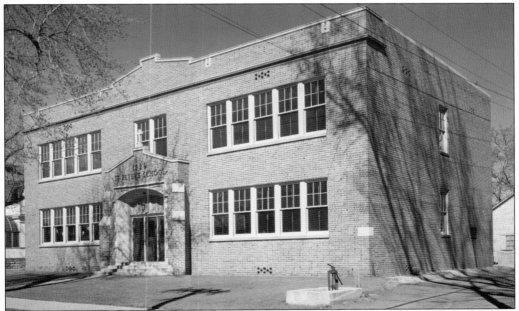

St. Peter's Catholic School, 1108 Ninth Avenue, was designed by Greeley architect Sidney W. Frazier. Five Sisters of Loretto taught 105 students in grades one through nine when the school opened in January 1927. It closed in 1986, when enrollment declined to 37 students.

In 1910, Rev. Benjamin W. Bonell started a seminary at Trinity Episcopal Church's rectory at 819 Eleventh Street. Enrollment grew, and Greeley Gas Company's manager, Paul Darrow, and other businessmen purchased 10 acres at the southeast corner of Eighth Avenue and Twenty-Second Street for a new seminary, the College of St. John the Evangelist. Four buildings were constructed between 1922 and 1924. The seminary closed in 1935. The Good Samaritan Society of the American Lutheran Church purchased it for $20,000 and opened Bonell Memorial Home for the Aged in October 1937.

Rev. Benjamin W. Bonell came to Colorado from Wisconsin in 1895 and spent several years in sanitariums recovering from tuberculosis. He was the rector of Trinity Episcopal Church from 1909 to 1922. Bonell's Episcopal seminary (1910–1935) educated 140 students who provided ministerial services for St. Albans, a church he founded in Windsor, Colorado, in 1910. A scholarly and charismatic pastor with a love of adventure, he took a trip around the world on a freighter at age 88.

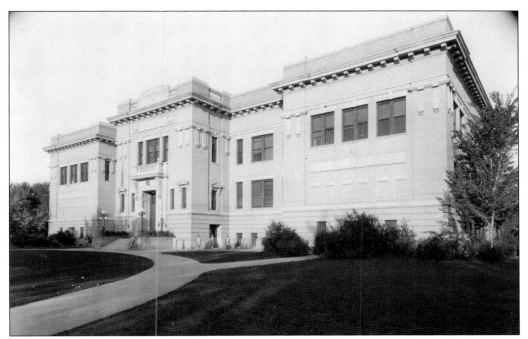

Greeley gained 5,000 residents between 1900 and 1910, and new schools became a necessity. School District Six purchased a block known as Meeker field in 1910. Denver architects Robert S. Roeschlaub and Son designed Greeley's third high school in an elegant classical style. Constructed in 1911–1912 at a cost of $140,000, it stood on Ninth Avenue between Fourteenth and Fifteenth Streets. In 1927, it became the Meeker Junior High School.

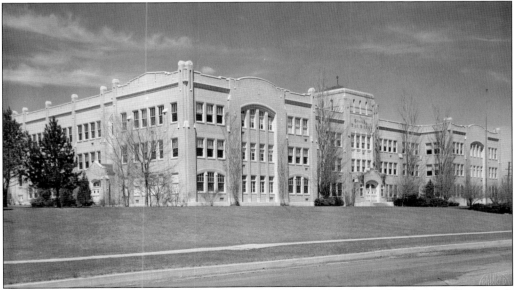

In 1926, Greeley citizens approved bonds to construct a new Greeley High School at Fourteenth Avenue between Fifteenth and Sixteenth Streets. William N. Bowman, a Denver architect affiliated with Greeley architect Sidney W. Frazier, drew the simplified Tudor-style plans for this $350,000 school, which opened in 1927. Its name was changed to Greeley Central High School in 1964.

Greeley architect Sidney Frazier incorporated modern Art Deco design elements into Greeley Junior High School at 811 Fifteenth Street, a Works Progress Administration project built in 1937–1938 as a new addition to the junior high school complex that also included Meeker Junior High School and the Eighth Avenue Gymnasium. School District Six administrative offices occupied the building from 1965 to 2001.

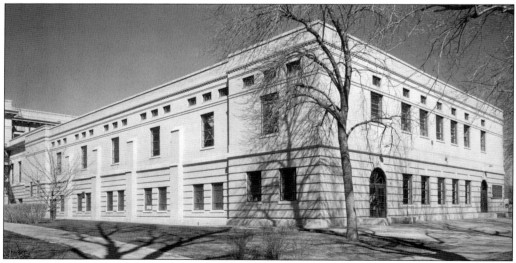

The 2,500-seat Eighth Avenue Gymnasium was used for athletic and other events. The Greeley Knights of the Ku Klux Klan rented it on February 16, 1925, for a minstrel show, orchestral music, and speeches enjoyed by 2,100 Klansmen and their guests. The Greeley Jaycees sponsored an exhibition game on January 8, 1961, between the Harlem Globetrotters and the Washington Generals, with singer Cab Calloway, a human balancing act, and four of the world's best table tennis players as the halftime entertainment. Built in 1925, it was razed in 1968.

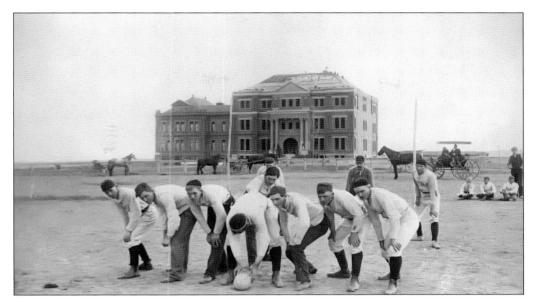

Denver architect Robert S. Roeschlaub designed Cranford Hall, the first building constructed on Arlington Heights at Colorado State Normal School. The east wing was built in 1891–1892, the central section in 1894–1895, and the west wing (not seen in this photograph) in 1902–1903 for a total cost of $90,584. The first football coach, Arthur I. Kendel, was hired in 1899. On March 6, 1949, an arson fire severely damaged the building. It was razed on June 16, 1973.

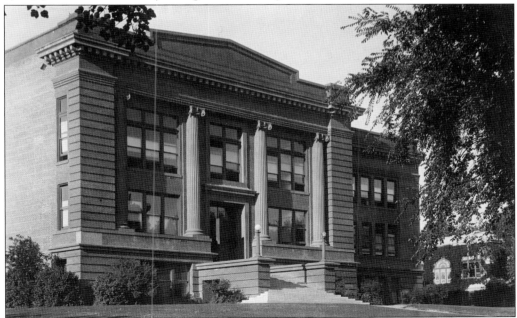

The training, or laboratory, school was named for Harry Kepner, president of the Trustees of the Colorado State Normal School. Designed by Colorado Springs architect Thomas P. Barber, it opened in 1912. An east wing was added in 1923. An inscription above the east entrance reminds future educators that "Whoso teaches a child labors with God in His workshop." Today, the Kenneth W. Monfort College of Business occupies Kepner Hall.

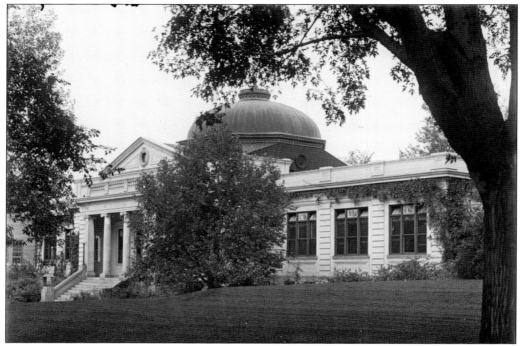

Robert S. Roeschlaub designed the library at the Colorado State Normal School. Located east of Cranford Hall, it was deemed an architectural gem in the Rocky Mountain region with its dramatic dome roof and tranquil reflecting pool on the north. The dome and pool were lost when the building (later named Carter Hall) was renovated into a "modern facility" as part of a Public Works Administration project in the 1930s.

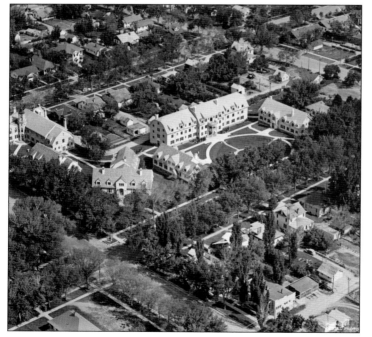

The Colorado State College of Education women's dormitories, seen in this 1936 photograph, were located on an attractive commons on Tenth Avenue between Nineteenth and Twentieth Streets. The first dorms were built in 1921 after college officials assured residents they would not adversely impact Greeley's lucrative rental market. The Colorado Federation of Women's Clubs named the residence halls after Frances Belford, Sophia Park Gordon, and Sara Platt Decker, all prominent leaders in suffrage, civic, and social causes.

During Pres. Darrell Holmes's tenure (1964–1971) at Colorado Teachers College, banker John M.B. Petrikin's 160-acre farm was purchased for $537,664 to develop the west or Holmes campus at Colorado Teacher's College. At the lower right (Twentieth Street and Eleventh Avenue) is Bishop-Lehr Hall, the new laboratory school and the first building on the west campus (1962). The University Center (1965) is east of Eleventh Avenue at the left.

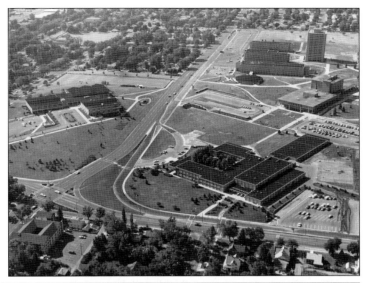

In the fall of 1967, Aims Community College opened in leased space at the Lincoln School with 930 students. In 1969, the school purchased 175 acres in west Greeley for $350,000 for its permanent campus. In 1971, Aims purchased the ITEL electronics fabrication building and 10 acres north of the water tower at Fifty-Fourth Avenue and Twentieth Street, seen in this 1976 aerial view. The ITEL building was remodeled for 30 classrooms, a library, a student center, offices, and a computer system for instruction and bookkeeping and was renamed General Services.

On December 12, 1961, voters approved $6.38 million for the construction of four elementary schools, one junior high school, and one high school. Architect John Shaver's unconventional and controversial round and geometric-shaped buildings put Greeley in the national spotlight for educational innovations that included modular and flexible buildings, wedge-shaped classrooms, fluorescent lighting, and advanced heating, ventilation, and acoustics. Brentwood School, seen here, had 12 classrooms with folding walls and a fan-shaped outdoor gym. Brentwood, East Memorial, Madison, and Sherwood Elementary Schools opened in 1963.

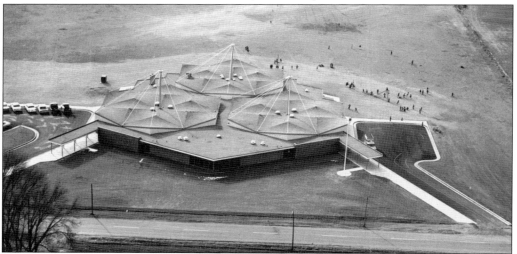

East Memorial Elementary School had six classrooms with an instructional materials center in each of its three windowless hexagons. One hexagon had primary grades, another intermediate grades, and the third kindergarten, music, kitchen, and multipurpose areas. This building replaced the Delta School and was named in memory of its 20 students who died when their school bus was struck and cut in half by a Union Pacific train on the morning of December 14, 1961.

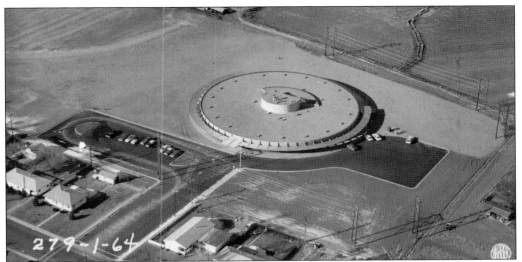

Madison Elementary School cost $581,000 and accommodated 420 students. It had six grades in 12 classrooms, plus kindergarten, all located along the outer rim of this giant, windowless wheel. Moveable folding walls separated all classrooms, and offices, the library, and the "cafetorium" were located at the center hub. Carrels of instructional materials and tables and chairs lined the circular corridor outside the classrooms.

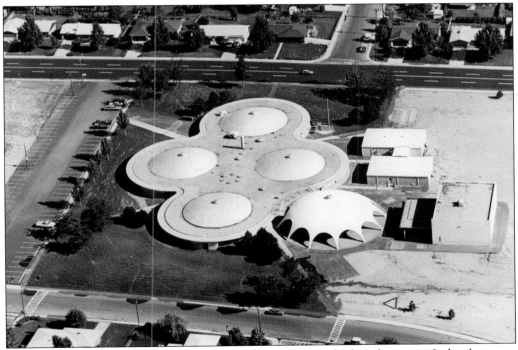

Sherwood Elementary School, with a capacity of 660 students, had 20 classrooms for kindergarten through sixth grade. One "pod" contained the kindergarten and administrative and health offices, the cafetorium, the kitchen, and music space. At the center of the primary grades' pod was a circular terraced theater. The "parachute" dome was a limited-shelter gym. The school was renamed in 1969 for its first principal, Wilma M. Scott.

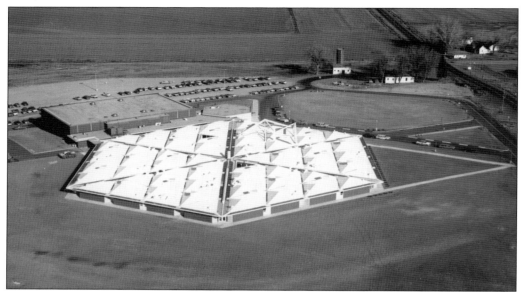

Greeley West High School opened in 1964 and was the most expensive ($1,757,000) of the Shaver-designed schools. Resembling a pastry tart, this hexagon of six triangles could accommodate 1,500 students in rapidly growing west Greeley. By 1970, all of the "new design" schools had become the district's nemesis. Greeley West was plagued by a leaky roof, inadequate lighting, and groundwater that seeped under the foundation and destroyed the gymnasium floor.

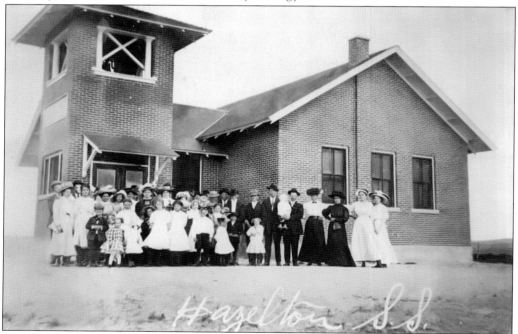

Hazelton School, built west of Greeley in 1909, was one of four rural demonstration schools affiliated with Colorado State College of Education. It was located on the southeast corner of Seventy-First Avenue and Highway 34. College students wishing to teach in isolated districts could do their "practice teaching" in these schools.

Four

AGRICULTURE

Agriculture proved challenging for the colonists. They survived four locust plagues in the 1870s and adopted farming methods suited to a fickle semiarid environment punctuated with periodic droughts, floods, hail, heat, wind, and blizzards. Potatoes, the first successful commercial crop, were shipped via railroad to markets in Colorado and throughout the United States. Agricultural laborers were needed by the mid-1880s, creating opportunities for new immigrants. The Scandinavians were the first arrivals and worked on farms, irrigation projects, and in businesses.

The ideal soil and climate of the South Platte and Poudre valleys launched the sugar beet industry in 1902. Thousands of skilled and strong Germans from Russia came to plant, block, thin, hoe, irrigate, and harvest beets. When these "stoop" laborers threatened to go on strike for better wages in 1903, Japanese workers were recruited from Denver and Utah to tend beets. By 1910, the expansion of agriculture and railroads in Weld County, the labor shortage created by World War I, and Colorado's mandatory school attendance laws opened the door for the arrival of Hispanic Americans and Mexican nationals displaced by the Mexican Revolution.

By World War I, sugar beets, requiring a long growing season and sufficient water, soon surpassed potatoes as the region's main crop. Beet tops and beet pulp, silage, and other crop surpluses were fed to sheep and cattle. In the 1930s, Warren Monfort and others experimented with the controlled feeding of cattle in lots to maximize weight gain, control disease, and ensure a steady supply of animals for market. "Finishing lots" revolutionized the cattle industry and created a stable local economy. Weld County ranks among the top 10 US counties in revenue derived through agricultural production.

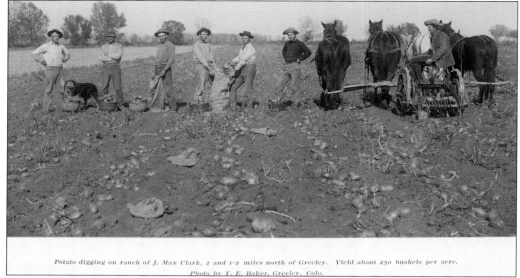

Potato digging on ranch of J. Max Clark, 2 and 1-2 miles north of Greeley. Yield about 250 bushels per acre.
Photo by F. E. Baker, Greeley, Colo.

In 1871, James Max Clark was one of the first to raise potatoes, but Ed Von Goren's banner crop in 1876 launched the local industry. Potato cultivation was challenged by many variables—weather, the Colorado potato beetle, and leaf roll virus. In 1889, local farmers spent $8,400 on 14,000 pounds of Paris Green (an arsenic compound containing copper) to fight the beetle. Greeley exported 300 railroad cars of spuds in 1883 and 10,000 in 1903.

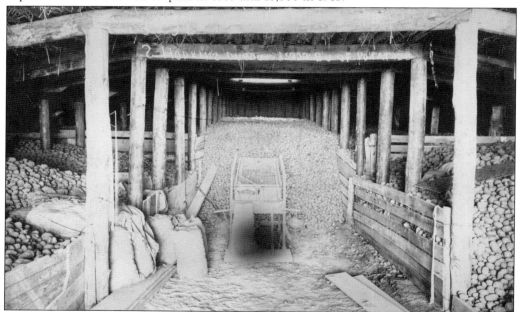

Harvested potatoes were stored in partially underground cellars with thick earthen walls, bins set over a false floor, low air intake vents and roof ventilators for proper temperature and air circulation to prevent rot. Sorting and sacking machines, as seen here, were produced by the Thompson Manufacturing Company in Greeley. The *Greeley Tribune* on December 9, 1897, boasted, "Go down into our potato cellars, bigger than Pennsylvania barns, and see the hundreds of thousands of bushels stored away for the winter and spring markets."

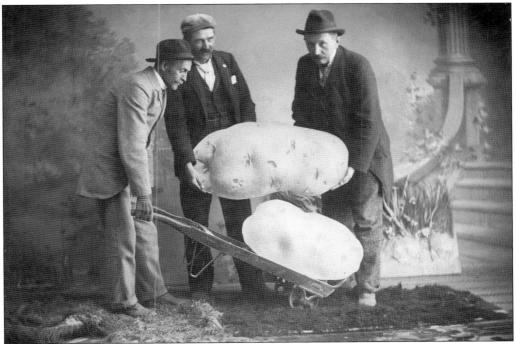

A Potato Day committee of prominent businessmen and farmers organized an agricultural festival in 1894 and 1895 that paid homage to Greeley's most profitable crop. From left to right in this boastful comical photograph of giant spuds are committee members William Boomer, barber; Fred Smith, farm implements dealer; and Dave Camp, Greeley city marshal.

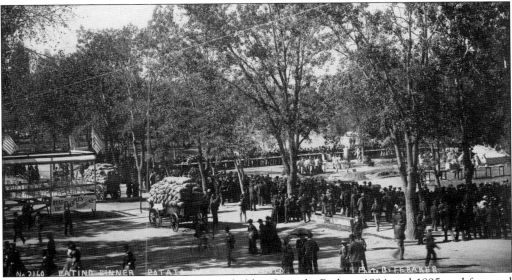

Greeley's largest Potato Day festivals were held in Lincoln Park in 1894 and 1895 and featured displays of locally grown potatoes, fruits, and vegetables, in addition to bicycle and foot races, a poultry show, tanks with live perch, bass, and trout, and musical entertainment. In 1894, organizers served barbecued mutton and beef, baked potatoes, bread and butter, and coffee to thousands of visitors, many who came from Denver via a special excursion train.

In 1880, James L. Ewing built a three-story brick elevator at 617 Fifth Street and purchased the adjoining 1875 mill built by Bruce Johnson. Ewing sold his Greeley Model Milling and Elevator Company in 1885 to the Colorado Milling and Elevator Company. One of its flour brands was Snow-Flake, "the housewife's delight." In 1968, D&D Bean Company purchased the Model Mills.

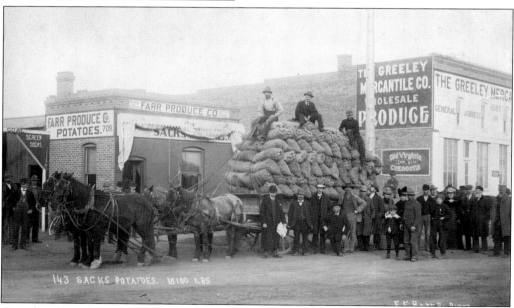

Canadian-born farmer and implement business owner William H. Farr and banker Charles N. Jackson established Farr Produce at 709 Seventh Street in 1891. It was one of five potato wholesale shipping firms, the others being the 1886 Greeley Mercantile Company, founded by Henry C. Watson; the 1888 Isidor Rothschild & Company (with partner Joe Woolf); the 1889 firm of John C. Mosher and Harvey D. Parker, and the 1890 Farmer's Mercantile Company, founded by Albert and Jerome Igo. Known as the "High Five," owners met daily to review railroad tariffs, inventories, and orders and set prices paid to farmers for produce, averting price wars between the companies.

Seeley Lake was constructed on Joseph Seeley's farm in 1873 as a reservoir for runoff from Union Colony Canal No. 2. In the 1880s, Seeley stocked the reservoir with perch and bass, and in 1894, he built a dance pavilion and boat dock and promoted it as Lakeside, a "charming resort for Weld County pleasure seekers." He harvested and sold quality "clear ice" from the lake, seen in this c. 1890s image.

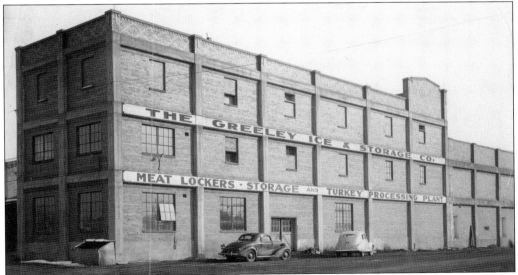

The Greeley Ice and Storage Company constructed the north end of this fireproof plant in 1930 and the south end in 1940. With 28 to 30 employees in 1930, the plant produced 1,500 tons of ice per day and had retail routes throughout Weld County. With a capacity of 300 carloads, potatoes, beans, vegetables, and eggs could be stored "indefinitely" in cold rooms insulated on the top, bottom, and sides with four inches of cork. The third floor had steel-clad lockers for furniture storage.

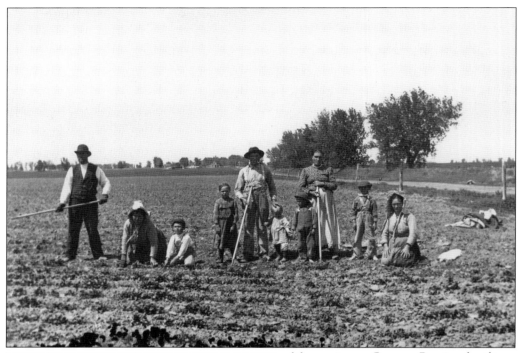

Many migrant German-Russian families, as seen here, were recruited by sugar company agents as seasonal beet field tenders. Cultivating beets was labor intensive, as each row of young plants had to be blocked with a hoe and thinned by hand, leaving only one healthy plant every 10 to 12 inches in the row. During the growing season, beets were irrigated as needed and hoed several times to kill weeds and aerate the soil. Laborers were paid by the number of acres specified in their contracts.

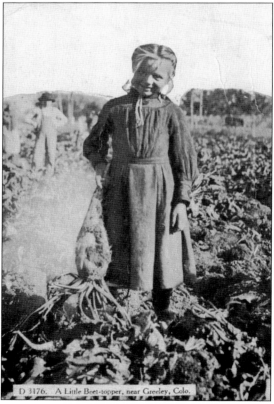

D 3176. A Little Beet-topper, near Greeley, Colo.

A small girl holds a large harvested sugar beet in this c. 1910 image. Children could straddle the rows to thin beets as required during the growing season. Beet thinners wore overalls with heavy padded fabric attached at the knees for protection.

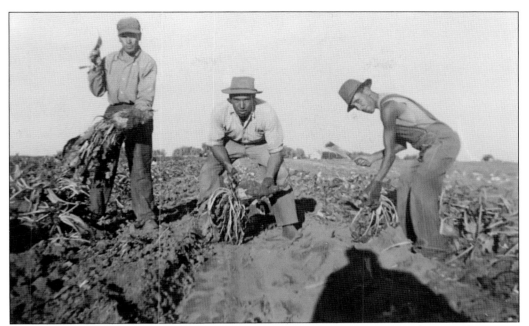

Beets were harvested in late September or early October. This c. 1930s image shows workers using machete-like knives. A sharp curved hook on the end allowed a worker to pick up a beet, grab it in one hand, and chop off the leaves at the crown. Topping beets was fast-paced, dangerous, dawn-to-dusk work for four to six weeks that required strength, skill, and good eye-hand coordination.

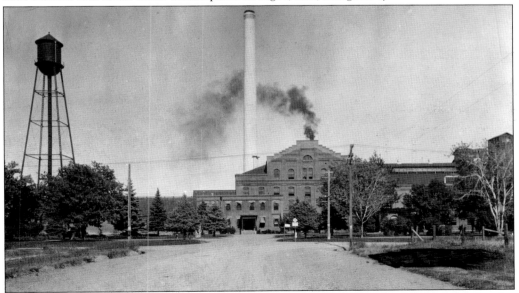

In May 1901, local businessmen and outside investors formed a new corporation, the Greeley Sugar Company, and hired an Ohio company to construct the Greeley Sugar Factory. It was built by black laborers who lived in a tent city, as they were not allowed lodging in local hotels or rooming houses. It opened on October 30, 1902, and could process 600–800 tons of beets per day. Corporate agriculture began in Weld County when the factory was purchased by the Great Western Sugar Company in 1905. It closed in 2003 and was razed in 2007.

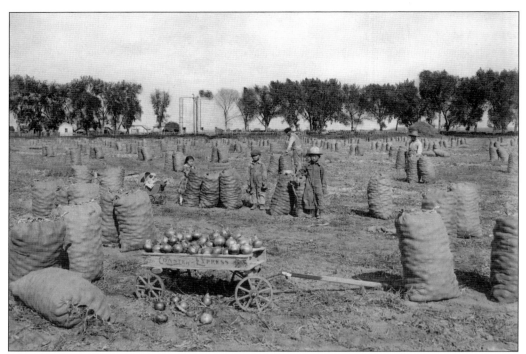

Many Japanese immigrants in Greeley and Weld County excelled as farmers, producing large yields of sugar beets, cabbage, and onions. Onions, seen in this c. 1910 image, were successfully cultivated throughout the Greeley district. In 1901, the Perrin brothers rented five acres in east Greeley on shares from William Insinger, planted 19 pounds of seed, and harvested a record-breaking crop of 1,850 sacks of onions.

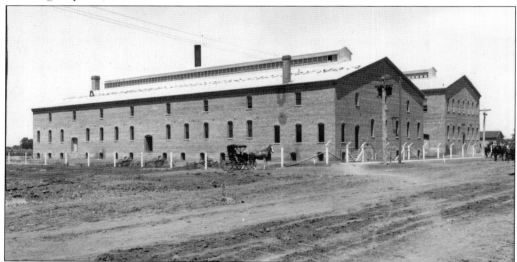

The Greeley Canning Company's new factory at Ninth Avenue and First Street opened in 1907. It was leased to the Empson Packing Company of Longmont, Colorado, which merged with the Kuner Pickle Company of Brighton, Colorado, to become Kuner-Empson Company in 1927. The company contracted with farmers to grow cannery crops—beans, red beets, cabbage, corn, peas, cucumbers, tomatoes, and pumpkins. It is now the North Weld Produce Company.

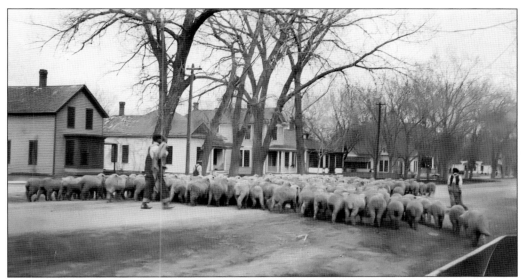

Starting in the 1880s, steady prices for mutton and wool boosted sheep feeding in Weld County from 90,000 head in 1898 to 150,000 head in 1905. Beet tops left in the fields after harvest and beet pulp from the sugar factory after 1902 provided winter feed. In March 1901, twelve thousand head of sheep were loaded onto 50 railroad cars at Greeley for shipment to Omaha and Chicago. Thirty-five of these cars (250 head per car) belonged to Benjamin H. Eaton, who scheduled a 30-day stop at one of the feeding stations along the way to fatten his sheep before they were sold.

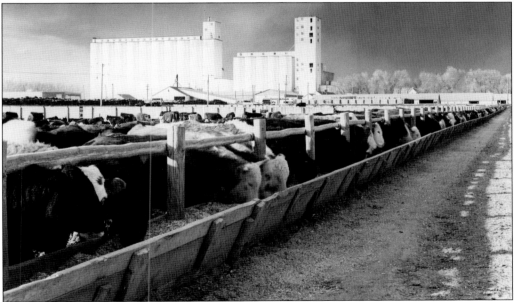

Warren Monfort purchased 18 steers and monitored their weight gain and health in a confined lot on his farm, using crop surpluses to finish them for market in 1930. His experiment launched the modern cattle feeding industry. By 1968, the farm had 360 acres of pens (the world's largest feedlot) where 200,000 head of cattle annually were fattened on a scientifically formulated diet of corn and silage for 145 days prior to slaughter. The original feedlot closed in 1974, and cattle were fed at two new 120,000-head finishing lots, one at Gilcrest and one at Kuner.

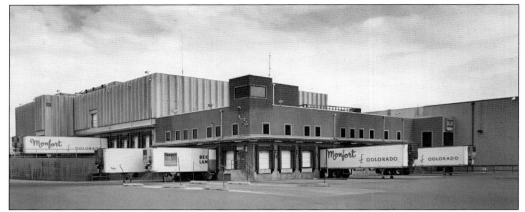

In 1961, Warren Monfort purchased Greeley-Capitol Pack, Inc. By 1964, Monfort of Colorado had doubled the size of the beef and lamb packing plant, which employed 425 people, contributed $85 million annually to the local economy, and transformed Greeley into Colorado's "steak capital." Under the charismatic leadership of Kenneth, Warren's son, the company pioneered in-house beef fabrication and packaging, sold its "boxed beef" with trimmed and portion-controlled cuts to stores and restaurants, founded its own trucking company and distribution centers, created global markets for Weld County beef, and became the largest exporter of beef to Japan by 1970.

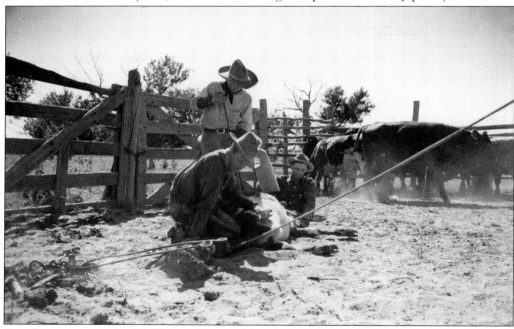

Branding a steer at the S.L.W. Ranch east of Greeley are, from left to right, Harvey Witwer Jr., Stow Witwer Sr. (with branding iron), and ranch hand Ben Fox. John M. Studebaker, Lafayette Lamb, and Harvey Witwer Sr. (Studebaker's nephew) formed the S.L.W. Ranch Company in 1899. An astute manager and partner, Witwer sold and/or leased 80- and 160-acre farms with water rights and became sole owner of the 13,651-acre ranch in 1913. From 1923 to 1942, Witwer and his sons Harvey Jr. and Stow Sr. operated one of Colorado's first dude ranches here. A Colorado Centennial Ranch listed in the National Register of Historic Places, the S.L.W. has the oldest registered Hereford herd in Colorado.

Five

WATER AND IRRIGATION

The first cooperative challenge faced by the Union Colonists was building irrigation systems and securing water rights. Greeley men of all ages, backgrounds, and experience helped construct Greeley's first ditch. By June 10, 1870, water was diverted from the Cache la Poudre River into the hastily dug No. 3 Ditch to water the town's yards and gardens.

In 1874, a heated conflict arose between Greeley and Fort Collins about who had the first right to divert and use water from the Cache la Poudre River. The dispute was resolved when all farmers met halfway—at the Windsor schoolhouse—to discuss priority water rights and other issues, which ultimately led to an equitable water doctrine for the state.

In *Colorado History and Government*, J.E. Snook said the Union Colony at Greeley was successful for three reasons: "It combined cooperation with individual ownership of land; as a corporation with a large amount of land which could be sold to its stockholders, it included a reversionary clause in property deeds which barred the public sale of liquors within its territory, and it was . . . the pioneer in large irrigation enterprises, its No. 2 canal being the first in America to scale the river bluffs and water the second bench or open prairie lands."

The drought and Dust Bowl of the 1930s forced northern Front Range residents to acknowledge the inevitable wet and drought cycles and address the need for more water. Businessmen and farmers lobbied Congress for help, and in 1937, the Colorado-Big Thompson Project was approved. Completed in 1957, this system of high mountain reservoirs and a transmountain water diversion tunnel brought water from Colorado's western slope for northern Front Range agricultural, municipal, and industrial use, even in periods of drought.

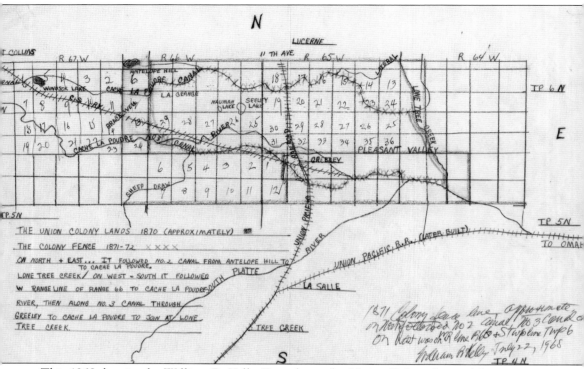

This 1968 drawing by William R. Kelly, Esq., shows the Union Colony fence. After receiving permission from the territorial legislature, in 1871, the colonists spent $20,000 and constructed 50 miles of smooth-wire fence to enclose the colony's lands and prevent livestock on the open range from destroying their crops. Longhorn cattle weren't deterred, and repairs were frequent. The fence was removed and sold in 1890.

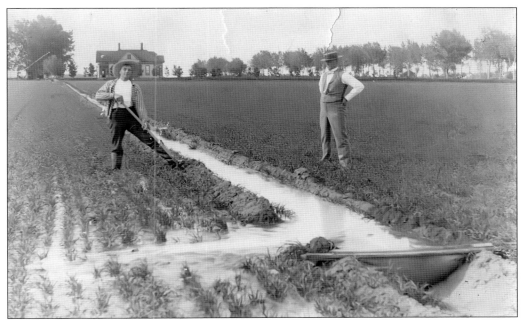

Ben Rienk (hands on hips) oversees the irrigation of wheat on his farm north of Greeley in 1897. The canvas dam was used to control flood irrigation in a field, and this image has been used in many books and publications as an iconic example of field irrigation.

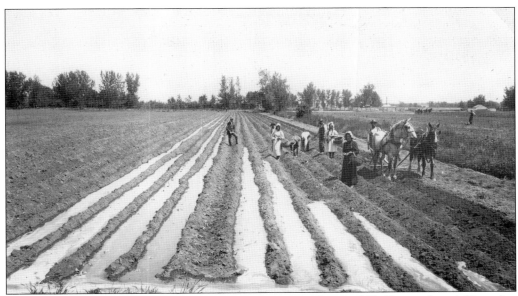

Born in the Netherlands, William Insinger came to Greeley in 1893. He purchased 10 garden tracts in east Greeley, which he rented to sharecropping tenants who raised cabbage, celery, carrots, onions, and cantaloupe. Educated and civic-minded, he helped finance the construction of Greeley's Main (Eighth) Street drain, which collected downtown groundwater, and in return, he was granted permission to use this water to irrigate his productive vegetable tracts. He was affectionately dubbed the "Duke of Stink Water."

A New Hampshire native, Col. Charles A. White had been a bobbin boy, cotton mill foreman, carpenter, mason, Civil War soldier, and an employee in the US Treasury Department prior to joining the Union Colony. A farmer and mason, he constructed many of the first houses, businesses, and churches in Greeley and served as postmaster (1884–1888) and mayor (1888–1889). He investigated municipal water systems in other towns and states, and during his term as mayor, Greeley built its first waterworks.

The Greeley Waterworks, located on the east side of Fourteenth Avenue and A Street, was built in 1888–1889 for $65,000. Two enormous pumps forced water from infusion chambers at the site into water mains in the streets, including one that filled the 138,000-gallon reservoir (stand pipe) on Normal Hill. Daytime capacity of the pumps was 45,000 gallons per hour, and nighttime capacity was 25,000 gallons. Pumps were shut down at midnight and restarted at 5:00 a.m. to refill the reservoir. Demand outpaced supply, however, as the city grew.

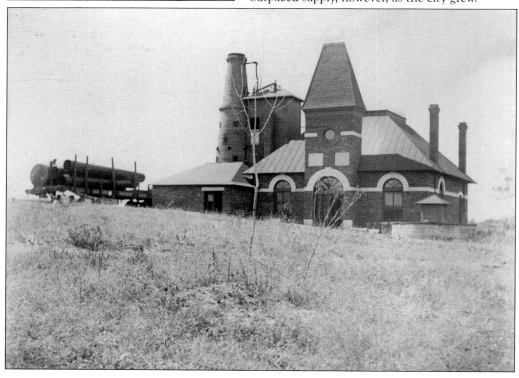

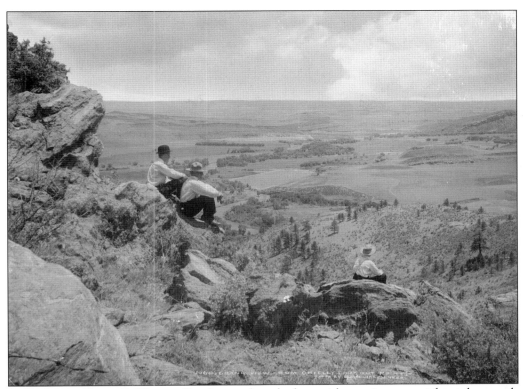

Led by Mayor Henry C. Watson, Greeley purchased a farm with a senior water right at the mouth of the Cache la Poudre River at Bellvue, seen here, and combined it with another senior water right to build a new $350,000 municipal water plant with three slow sand filtration basins in 1907. Approximately 38 miles of 20-inch-diameter wood stave supply mains brought water by gravity flow to the town's new reservoirs at Twenty-Third Avenue and Reservoir Road.

Milton Seaman, Greeley's water and sewer superintendent, inspects a section of rotted infrastructure, a stave pipe made of fir, banded with steel, and coated with tar that was manufactured at Island Grove Park and used for the water transmission lines from Bellvue to Greeley and throughout the city in 1907. Over the years, deteriorating stave lines were replaced with steel pipe.

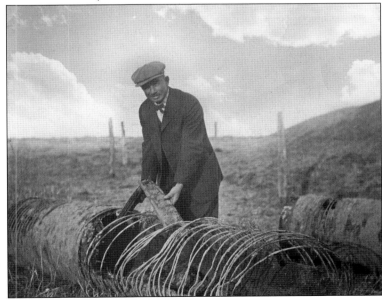

Union Colonist James Max Clark called his 80-acre farm near Greeley Poverty Flats. Convinced this region could be transformed into a bountiful oasis, he made a scientific study of irrigation in the 1870s and kept detailed records of his farm expenditures and crop yields. He invented a flume and advertised his patented irrigation shovels in the *Greeley Tribune*, where he was editor from 1890 to 1900. In the 1890s, he cross-fertilized two melons and created the "Greeley Wonder Melon." Clark recounted Greeley's locust plagues, droughts, blizzards, crop failures, and people in his book *Colonial Days*.

Delphus E. Carpenter was the son and grandson of Union Colonists. An 1899 graduate of the University of Denver Law School, from 1908 to 1911, he served as the first native-born senator elected to the Colorado State Senate, where his career as a brilliant water law attorney was launched. Known for crafting interstate compacts that provided for the equitable distribution of water from river drainage basins in the West, Delph was the primary author of the 1922 Colorado River Compact. He had land, livestock, and irrigation interests in the Crow Creek area northeast of Greeley and, by 1918, owned one of the best purebred herds of Bates shorthorn milking cattle in the West.

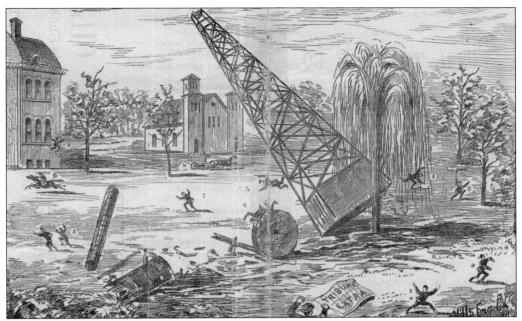

A *Greeley Tribune* extra edition was published in 1884 to commemorate the opening of the first of eight artesian wells in downtown Greeley. This 1,200-foot-deep well, drilled by the Swan brothers in the south half of Lincoln Park, cost $8,000 and was the town's source of pure water. With heavy use, flow diminished, and in 1901, the casing on the artesian pump failed and contaminated the well with groundwater. Repairs, estimated at $3,000, prompted city officials to look for a new source of municipal water.

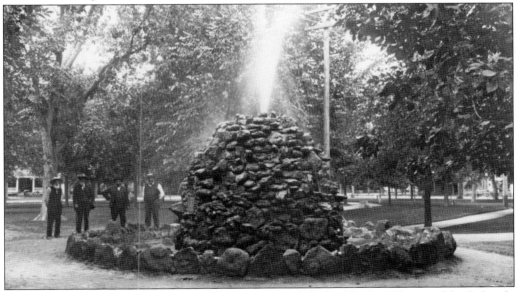

The 1907 Pioneer Fountain was designed in the grotto style by Prof. Richard Ernesti of the Colorado State Normal School at the site of Greeley's first artesian well. It was constructed of rocks and interesting donated specimens that included ore samples from Colorado, England, and Africa, shells from Maine, crystals, granite, a petrified snake, a metate, and other trinkets.

Charles Hansen, a newspaperman from Grand Rapids, Michigan, came to Greeley in 1902, and became publisher of the *Greeley Tribune-Republican* in 1917. (The merger of the *Greeley Republican* with the *Greeley Tribune* led to the establishment of the *Greeley-Tribune Republican* in 1913.) In the 1930s, Hansen used his newspaper to promote a trans-mountain water diversion project. In 1937, the Colorado-Big Thompson project (C-BT) was authorized by Congress, and it ultimately supplied northeastern Colorado with water from the Western slope. The Northern Colorado Water Conservancy District, the administrative arm of the C-BT, was located in the Greeley Tribune building from 1938 to 1954.

Charles Hansen hired Greeley architect Sidney G. Frazier to design a modern newspaper plant when the Tribune-Republican Publishing Company outgrew its rented space in the basement of the Camfield Hotel. The $79,839 Greeley Tribune building, with its beautiful beaux arts facade, was built in 1928. The *Greeley Tribune* relocated to a new facility in 1986. In 2004, this 1928 building was renovated, and it opened as the new Greeley History Museum in July 2005.

Six

COOPERATION AND CAMARADERIE

Cooperation and camaraderie are hallmarks of Greeley and have advanced its community aspirations and projects. Nathan Meeker encouraged colonists to form fraternal, social, civic, and educational clubs and organizations. The Greeley Lyceum, Farmers Club, Good Templars, Silver Cornet Band, and scores of other groups sprang into existence during the 1870s.

Citizen initiatives supported and raised money to establish the Colorado State Normal School. In 1900, the Meeker Memorial Library Association recruited local club women to collect and preserve historical documents and artifacts about the founding and development of Greeley. The Greeley Public Library was privately funded in 1907. Five volunteer hose companies trained members and raised money for fire and rescue equipment prior to the establishment of the Greeley Fire Department in 1913. The Exchange Club of Greeley and the Greeley Garden Club cooperated to raise money and develop Glenmere Park in the 1930s.

Beginning in 1910, the Greeley Mothers' Congress lobbied for social reforms, vocational education, better sanitary and health practices in schools, and more parks and playgrounds for students. That same year, the German-Russians in east Greeley petitioned the city for a water main, and both men and women dug the required trenches in two days, receiving tax credits for their civic investment. The Spud Rodeo Committee's volunteers helped the chamber of commerce produce an annual Fourth of July celebration beginning in 1922 that has evolved into the Greeley Stampede. In 1949, there were 83 active clubs in Greeley.

In 1975, citizens assisted the city in seeking funding and private donations of buildings and artifacts to establish Centennial Village as a Colorado Centennial–US Bicentennial project. By the 1980s, determined citizens raised support and money to build the Union Colony Civic Center, which opened in 1988.

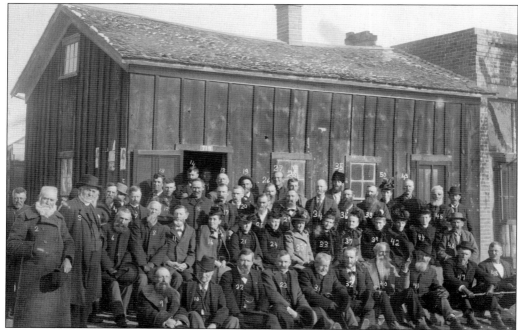

A 16-by-24-foot homestead shack obtained from Evans, Colorado, was moved to the southeast corner of Eighth Avenue and Eighth Street in 1870. Partitioned by a curtain, one side was used for the Union Colony office, and the other was used as a reception room for newcomers and later as the colony's first reading room. It was moved in the 1880s to 715 Eighth Street, where colony members assembled for this photograph on December 3, 1894, before the building was razed.

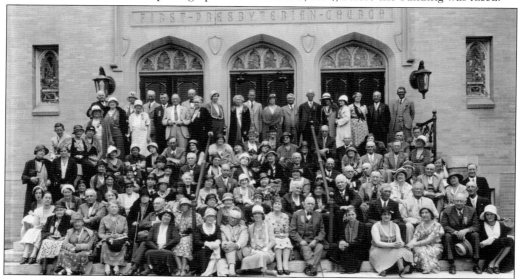

Original Union Colony members renewed the organization's corporate charter and founded the Union Colony Pioneer Society in 1890. Around 1930, members gathered for a group portrait on the steps of the First Presbyterian Church. Union Colony descendants, members, and guests meet annually on or near June 10—the date water was diverted from the Cache la Poudre River into the No. 3 Ditch in 1870.

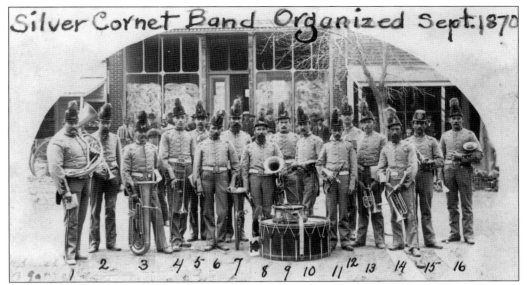

The Greeley Silver Cornet Band, seen in this 1880 image, was organized with 15 members in September 1870. Musicians and 42 citizens contributed $778.75 to purchase 13 instruments and two drums. If a member quit, his instrument remained with the band, and he was reimbursed for his original investment. The band's strict bylaws imposed fines for vulgar language, improper conduct, and missing practices.

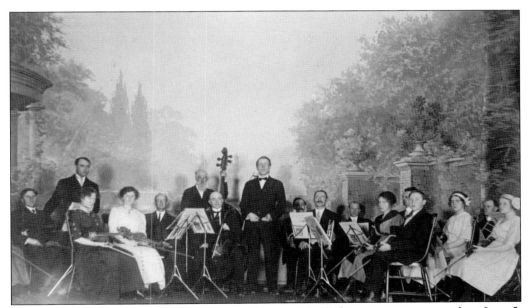

The Greeley Philharmonic Society, seen in this c. 1913–1915 image, was organized on June 5, 1911, and the Greeley Philharmonic Orchestra (GPO) held its first rehearsal with 14 musicians in the home of its first director, John C. Kendel. Kendel, a Greeley native, was an accomplished choral director. The GPO is the oldest continuously performing orchestra west of St. Louis and remains a community icon.

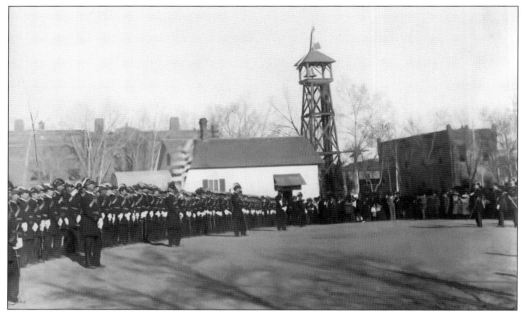

Around 1895, the Greeley Canton of the Patriarchs Militant of the International Order of Odd Fellows practiced drills, formations, and marching on the parade ground west of the 1879 city hall (next to the fire bell tower). It was the first fraternal organization in the Poudre Valley, chartered on April 26, 1871.

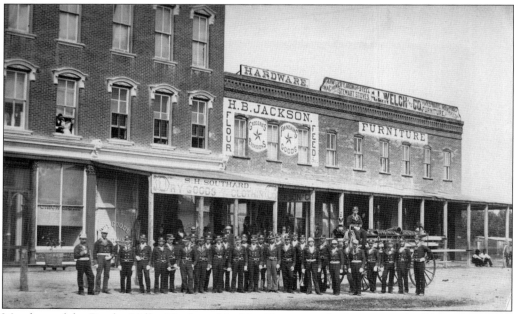

Members of the Poudre Valley Hook and Ladder Company, also known as the "Boomer Hooks" after its captain, William M. Boomer, are seen in this 1880s image taken on the west side of Eighth Avenue between Seventh and Eighth Streets. The city funded a fire station and equipment but relied on five volunteer hook-and-ladder and hose companies until paid professional firefighters were hired in 1913.

In the 1920s, the Greeley Chamber of Commerce, established in the fall of 1919, was located in the Camfield Court Building, constructed opposite the Camfield Hotel in 1911 at Eighth Avenue and Seventh Street. Daniel A. Camfield's bank and other businesses occupied the first floor, with apartments on the second floor.

Members of the Greeley Commercial Club convened at the Orpheum Theater in 1913. Organized by the five wholesale potato shipping firms, the club lobbied for new industries and projects that improved Greeley's economy, infrastructure, and quality of life. The slogan, "Greeley— always sober, never broke," appeared on the club's 1915 brochure.

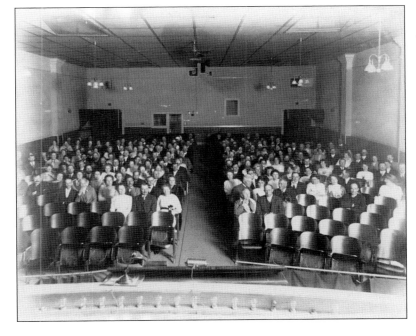

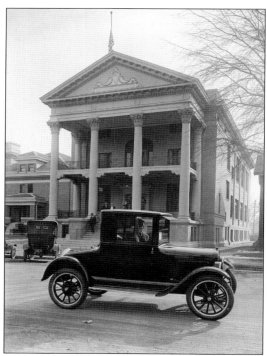

Greeley architects J.A. Wetzel and W.B. Patterson designed the $58,000 Benevolent Protective Order of Elks lodge at 922 Ninth Street. Eight members from local lodges started the Greeley Elks Lodge, No. 809, with 40 members in 1902. The new lodge was dedicated on July 4, 1912, with 543 members. With 2,300 members in 1964, a new $1.2-million lodge was built at Thirty-Fifth Avenue and the Highway 34 bypass. The 1912 lodge was purchased by Weld County in 1964 and remodeled for the expansion of county services. It was razed in 1973.

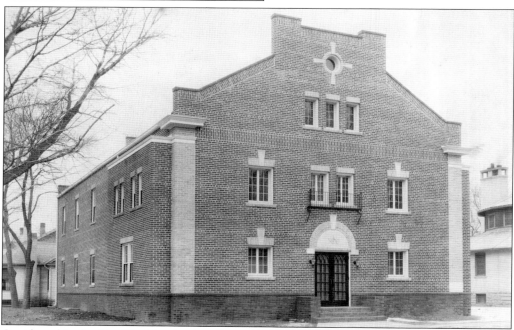

Occidental Lodge No. 20 of the Ancient Free and Accepted Masons was chartered on September 26, 1871, and met in rented quarters in various downtown buildings. In 1927, the Masons hired William H. Bowman, architect of the Weld County Courthouse, to design the $30,000 lodge. The Masons sold the lodge, located at the northwest corner of Tenth Avenue and Ninth Street, in 2015.

The Meeker Memorial Library Association was established in 1900 to collect historical materials about Greeley and Weld County pioneers. Memorabilia is displayed at the association's booth at a library fair in this undated photograph. From left to right are Lucetta Wood Bassett, Emily Jones, Susan Gale Adams, and Elizabeth Plumb Haynes.

The Knights of Pythias, seen in this c. 1930s image, met above the Greeley Dry Goods Store at 816 ½ Ninth Street.

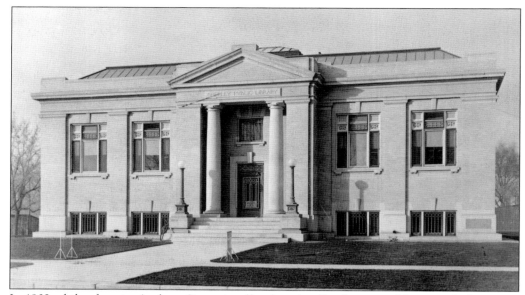

In 1902, philanthropist Andrew Carnegie offered to give Greeley a new library with the caveat that the city pay a certain percentage of the library's annual operating budget. Citizens met and unanimously declined his "strings attached" offer. A "buy a brick" campaign organized by local club leaders raised over $17,000 from 425 citizens to fund the Greeley Public Library by popular subscription. Built in 1907–1908, the library was razed in 1968.

Local businessmen, seen in front of the Greeley Bowling Club, 1117 Eighth Avenue, volunteered to produce and promote a Fourth of July event, the Spud Rodeo, starting in 1922. Tom Mawson, chairman of the 1941 event, hauled his horse, Dix, to area rodeos to advertise Greeley's Spud Rodeo, the "Biggest Annual 2-Day Celebration in the West."

The Greeley Business and Professional Women's Club was chartered with 61 members on March 2, 1926. Its goals were intellectual, social, and business advancement for members plus philanthropic work, including educational loans. In February 1937, members presented an international program dressed in costumes representing their native countries.

In 1957, the Greeley Business and Professional Women's Club toured the Weld County Jail. Civic participation, knowledge of, and support for the community and its businesses, and philanthropy were hallmarks of this organization.

In 1910, Glenmere Park, laid out on a curvilinear plan, was annexed into the city, and its 17 acres, purchased in 1907–1908 by the Glenmere Park Association, were deeded to the city. An unidentified woman is looking north across the island in Glenmere Lake, around 1935–1940. The WPA provided the majority of the $6,461 to build three dams and a pavilion and to seed grass in 1936.

The bicentennial of George Washington's birth was commemorated in 1932 when the Exchange Club and Greeley Garden Club campaigned for individuals and organizations to donate and plant 160 trees to develop Glenmere Park. In 1934, this project won fourth prize out of 148 cities that entered a national beautification contest sponsored by *Better Homes and Gardens* magazine.

In 1940, Kay McElroy organized the Greeley Saddle Club, seen here, when she was director of recreation for Island Grove Park. She accepted the job under the condition that horses be allowed in Island Grove Park. McElroy is seated at the far left in the front row in this c. 1940s image.

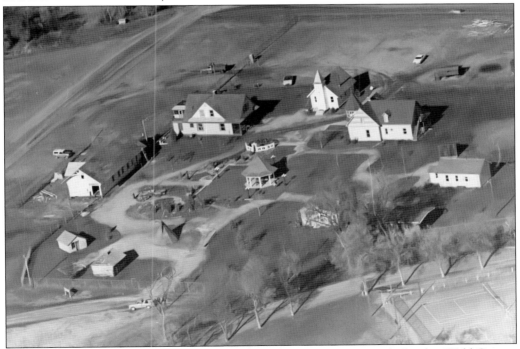

Centennial Village Museum had 14 structures, seen in this 1979 image. A Greeley–Weld County Centennial-Bicentennial "living history" project established on 10 acres adjacent to Island Grove Regional Park, the village has more than 30 structures in 2015. It opened on July 4, 1976, to preserve and interpret the architectural, cultural, and ethnic history of this area between 1860 and 1940.

After several failed initiatives, the Northern Colorado Foundation led a "Keep Our Community Moving Forward" campaign that secured $5 million from over 600 individuals and businesses to build the Union Colony Civic Center, seen here. In 1986, voters approved low-interest municipal bonds for the remainder of this $9.2-million project. Designed by ARIX and constructed by Hensel Phelps Construction Company, both Greeley firms, it opened in September 1988. It includes the Monfort Concert Hall, Hensel Phelps Theater, Tointon Gallery for the Visual Arts, and the Two Rivers Lounge and is the home of the Greeley Philharmonic Orchestra.

Seven

GREELEY HOMES AND PEOPLE

Nathan Meeker, a proponent of home and family, stated in his article "A Western Colony" that "happiness, wealth and the glory of a state spring from the family" and that individuals should labor to "make the home comfortable, to beautify and adorn it, and to supply it with whatever will make it attractive and loved."

For home building, inside lots ($25) and corner lots ($50) were sold to Union Colony members, who could also take advantage of the Homestead Act of 1862 or bid at auctions on colony-owned lands adjoining the town. In June 1870, there were 30 tents, 150 houses under construction, and about 500 people in Greeley.

Many large Italianate, Queen Anne, and vernacular Victorian eclectic–style homes, as well as new subdivisions, such as Gardenside west of Fourteenth Avenue, were built in the prosperous 1880s. Plumbing and electricity were commonplace in homes by the 1890s. From 1900 to 1909, construction boomed (100–200 new homes annually) in the residential neighborhoods surrounding the Colorado State Normal School and to the west. East Greeley, between the railroad tracks and the Great Western Sugar Company, was dubbed "Little Russia," as many German-Russian immigrants lived there after 1904.

Following the Great Depression, Colonial and English Revival–style homes were popular. Materials rationing during World War II, however, halted most new construction. One of the first subdivisions after the war was Alles Acres. The 160-acre Alles farm was parceled into one-acre lots for $600 each where owners were allowed to farm and keep livestock, combining city conveniences with rural amenities. Hillside and other subdivisions in the 1950s and 1960s incorporated modern trends, including good roads, homes with attached garages, and close proximity to neighborhood schools, parks, churches, and shopping malls.

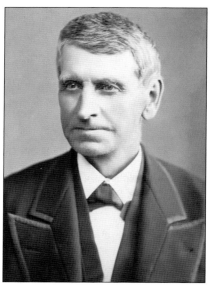

Socially shy and lacking charisma, Nathan Cook Meeker was a solitary and honest man whose visionary ideas inspired the establishment of Greeley. In 1878, Meeker needed to repay a number of creditors and secured a steady government job as the agent at the White River Ute Agency in western Colorado, where he was instructed to restrict the nomadic Utes to the reservation and teach them farming. On September 29, 1879, the Utes killed Meeker and the male employees at the agency. Meeker, Colorado, and Mount Meeker are named in his honor.

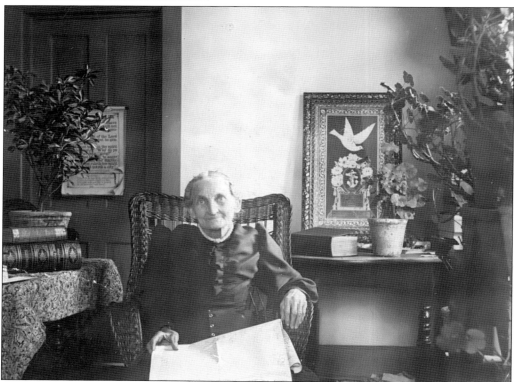

Well educated and resilient, Arvilla Delight Smith Meeker began married life at the Trumbull Phalanx in Ohio, where two of her five children were born. In Greeley, she was a devoted homemaker, raised small fruits and vegetables, kept bees, and was involved in Greeley and Colorado suffrage organizations. Held captive by the Utes after her husband was killed in 1879, she was released 23 days later and returned to Greeley. Arvilla died in 1905 in White Plains, New York, where she had spent the last year of her life with her son, Ralph.

Arthur Hotchkiss built this two-story adobe home for $6,000 in 1870 for Nathan Meeker at 1324 Ninth Avenue. As lumber was scarce and expensive, Meeker encouraged colonists to build with adobe. His house was largely an experiment, and the east wall collapsed and was rebuilt. A two-story brick addition with a bay window, bath, and dressing rooms was built in 1884. The house became Greeley's first museum in 1929.

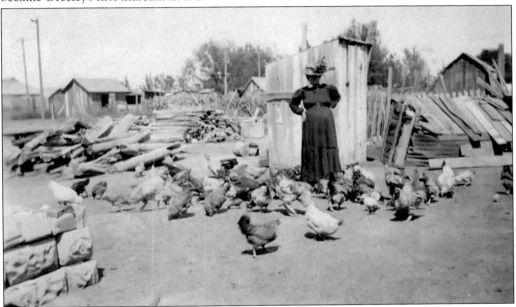

Rozene Meeker, Arvilla and Nathan's eldest daughter, passionately advocated for women's suffrage and education in articles she wrote for her father's paper, the *Greeley Tribune*. In 1886, she married Edward Skewes, a miner, but she later divorced him. Her jams and jellies won prizes at the Weld County Fair, and her skills as a seamstress and lace maker were widely recognized. Rozene cared for her mother, Arvilla, from 1879 to 1904. Here, she is feeding chickens at her home at 229 Thirteenth Street. Rozene died in 1935.

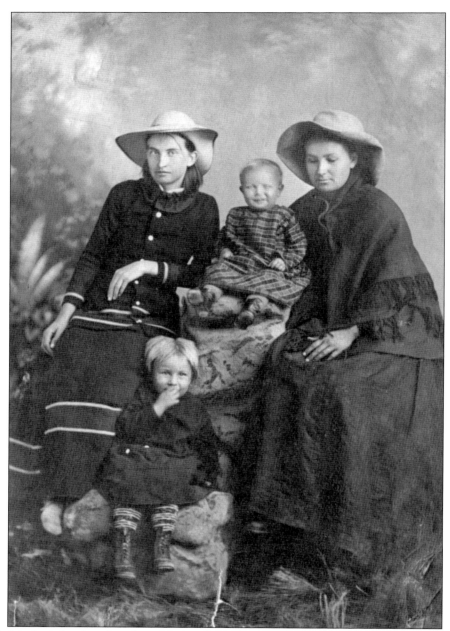

Arvilla Meeker's daughter Josephine Meeker (left), Flora Ellen Price (right) and Flora's two children May (bottom) and Johnnie (top) were taken, along with Arvilla Meeker, and held as captives by the Utes following the September 29, 1879, Meeker Massacre at the White River Ute Agency. After they were rescued, the women were photographed in the Denver, Colorado, studio of William Henry Jackson. During their captivity, Josephine and Flora Ellen made dresses for themselves from woolen blankets taken from the agency, as the Utes said they would keep the women in a mountain camp all winter. Josephine wrote a book about her experiences with the Utes and did a lecture tour in Colorado. She died of pneumonia in December 1882 in Washington, DC, where she had worked as a secretary in the Department of the Interior since 1880.

Henry Luther's home was built in 1892 at 2127 Eleventh Street. Part of his farm became Luther Park in the 1940s. Tenth Street was extended through the park in 1947, landscaping started in 1949, and the city council proposed building a brick or stone entrance, as West Tenth Street, known as the Greeley-Loveland Highway, was a major corridor into the city.

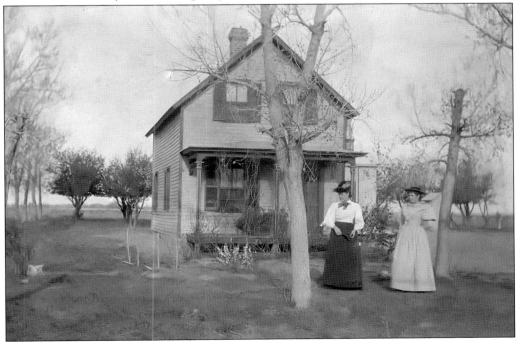

Pitts and Almina Smith sold their farm in north Greeley and moved to this home on a four-acre block at 228 Thirteenth Street in east Greeley in 1882. Their daughters Amy (left) and Luna (right) were teachers.

David Boyd emigrated to the United States from Ireland in 1851. A Civil War veteran, he served 18 months with the 18th Michigan Infantry, then became a captain in the 40th US Colored Troops. He excelled in the classics, writing, and farming, served as president of the Greeley School Board and the State Teachers Association (1880), and was Weld County superintendent of schools. Boyd supported women's suffrage, wrote many irrigation articles, and published two books: *A History: Greeley and the Union Colony of Colorado* (1890) and *Irrigation Near Greeley, Colorado* (1897).

Henry T. West was a member of the locating committee, surveyed the Union Colony lands, helped lay out the town, and insisted that two blocks be reserved for Lincoln Park. He hoped to go into the cattle business but was persuaded to open Greeley's first bank in partnership with Dr. Charles Emerson and Charles Buckingham. He was president of the Union Colony Pioneer Society for 22 years.

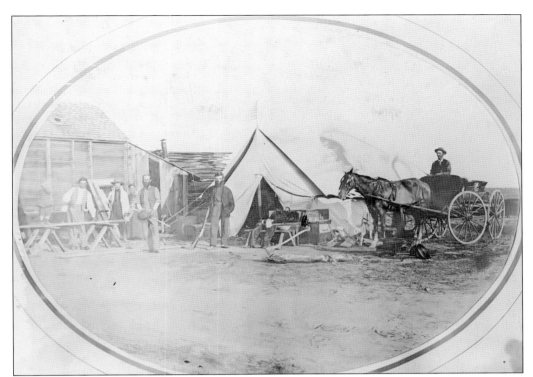

John Leavy was the first person to write to Nathan Meeker about joining the Union Colony. Born in Dublin, Ireland, he attended Trinity College and studied botany. Leavy, holding a rifle, flew the American flag from the ridgepole of his tent on July 4, 1870, in Greeley.

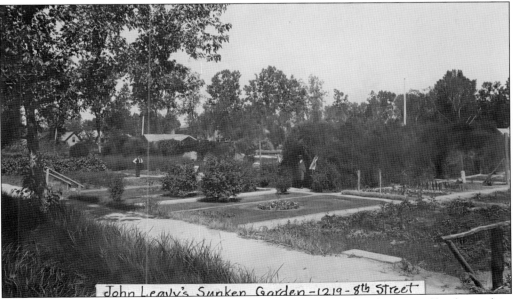

John Leavy, florist and philosopher, was called the "Sage of Greeley" because of his long white beard and his kind and generous disposition. This 1894 image depicts his sunken gardens at 1219 Eighth Street, also the location of his greenhouse and vine-covered home.

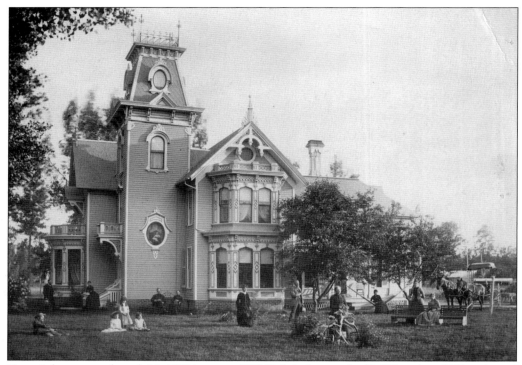

Bruce Johnson purchased this 1878 home at 1029 Eighth Avenue for $2,000 and, in 1882, enlarged it to 12 rooms and installed gas lights and plumbing. Johnson, a civil engineer, teacher, and friend of Horace Greeley, freighted supplies to Colorado's goldfields in 1859. An entrepreneur, he went into the cattle business with Jared and William Brush, established the Colorado Milling and Elevator Company with John K. Mullen, developed water storage and irrigation projects, and was president of Greeley's Union Bank for over 60 years. The home was moved to 715 Fifteenth Street in 1936.

A new job brought Hazel E. Johnson (1902–2002) here in 1938. She enthusiastically adopted Greeley as her home and local history as her hobby. Her history columns were published weekly in the *Greeley Journal* (1958–1979) and monthly in the *Senior Voice* (1980–1999). She donated her artifact and photograph collections to the Greeley Museums in 1991, and the Hazel E. Johnson Research Center is named in her honor. Behind Johnson is the 1886 Frank Lemmon home, 1203 Ninth Avenue. Lemmon raised sheep and cattle, and he hunted bison with Col. William F. Cody, also known as "Buffalo Bill."

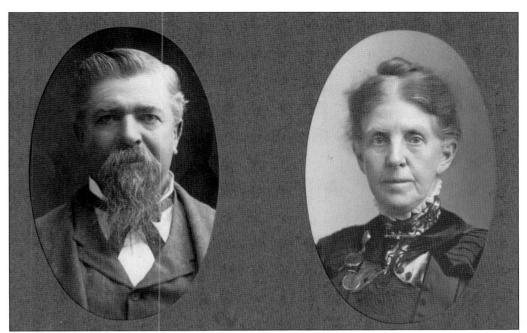

Benjamin Harrison Eaton and his wife, Rebecca Hill Eaton, settled south of present-day Windsor, Colorado, in 1864 on his claim near the Cache la Poudre River. Ben was an accomplished miner, farmer, cattleman, politician, and entrepreneur but excelled in the development of irrigation ditches and reservoirs. He helped the Union Colonists construct ditches, helped build the Larimer County Canal No. 2 in 1873, and secured British investors to construct the 52-mile Larimer and Weld Canal (1878) and the High Line Canal in Denver (1879). He built Windsor Reservoir and became Colorado's fourth governor (1885–1887). The town of Eaton, Colorado, is named for him.

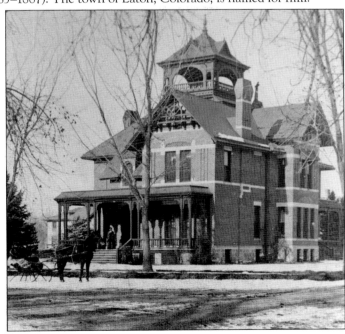

In 1878, the Eatons moved to Greeley. In 1880, Robert S. Roeschlaub designed their $20,000 home, the largest in Greeley at the time. It had plumbing and Greeley's first gas lights. Benjamin Eaton died on October 29, 1904, and 500 friends gathered for his funeral, held at his home at 805 Twelfth Street. The cortege to Linn Grove Cemetery was two miles long. The home was razed in 1953.

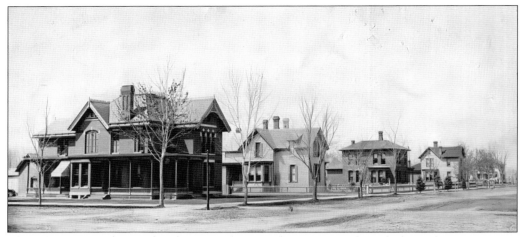

These homes, on the south side of Ninth Street between Tenth and Eleventh Avenues, are representative of 1880s home-building trends in Greeley. From left to right, the homes belonged to Judge James C. Scott, Calvin Randolph, Burton D. Sanborn, and William Henry Harrison Bliss.

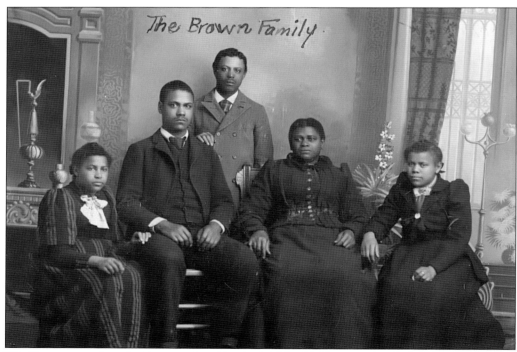

The Browns pose for a family portrait at Charles M. Marsh's Photography Gallery when they lived in Greeley in the 1880s. There were very few black families living in Greeley or Weld County at this time. In the 1880s federal census, Elvira Brown's occupation was listed as "laundress."

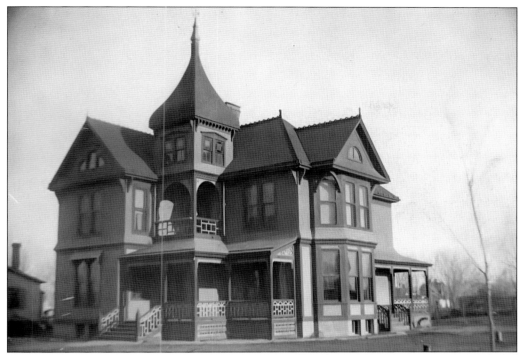

The M.P. Marshall home, 728 Eleventh Avenue, was built for $7,000 in 1887. Its amenities included a second-floor 54-foot tower open on two sides, a water tank in the attic, hot and cold water, steam heat, plumbing, and a cellar with a coal room, furnace, and laundry room. It was razed in 1922 for an automobile dealership.

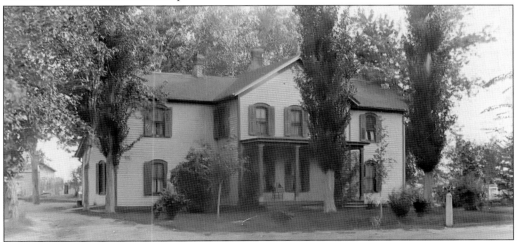

Jared Brush came to Colorado with his brothers in 1858 seeking gold along Russell Gulch. Next he freighted mining equipment, food, and merchandise to Colorado's new towns with his partner, Bruce Johnson, and later, he established a cattle ranch near Fremont's Orchard, east of Greeley. Brush moved to Greeley in 1870, when he became the Weld County sheriff. He was a Weld County commissioner for nine years, a state legislator for two years, and Colorado's lieutenant governor for two terms. The town of Brush, Colorado, is named for him. His Greeley home, seen here, was located at 1526 Eleventh Street.

Pioneer physician Dr. Jesse Hawes arrived in Greeley in 1872. He wrote many articles for medical journals and chronicled his Confederate prison experiences in his book *Cahaba: A Story of Captive Boys in Blue*. He served on the boards of several state medical organizations and taught obstetrics at Denver University. Interested in modern medical practices, he poses in his "antiseptic suit for use in treatment of contagious diseases."

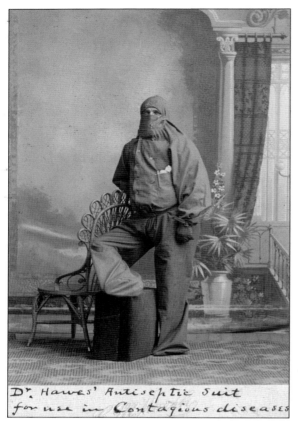

Dr. Hawes' Antiseptic Suit for use in Contagious diseases

Dr. Hawes built a new home and office (right) at the southwest corner of Eighth Avenue and Ninth Street in 1885. This image, looking south, was taken from the Samuel D. Hunter building. Hawes's neighbor at the east end of the block was Thomas G. Macy, an undertaker.

Greeley native Bessie Smith (1882–1921) completed an International Correspondence School architecture course, trained with the Baerresen Brothers firm in Denver, and joined her father in his firm, Hall and Smith Contractors, in Greeley in 1903. One of Colorado's first "lady architects," she designed commercial and residential structures in Greeley before moving in 1910 to San Diego, where she died in 1921.

The 1907 "ten-room modern" home of Samuel H. Southard at 1103 Ninth Avenue was Bessie Smith's largest residential commission and cost $13,500. Southard was elected Weld County treasurer in 1877 and moved his dry goods store from Erie, Colorado, to Greeley in 1878. He also held other offices, including county clerk and county commissioner.

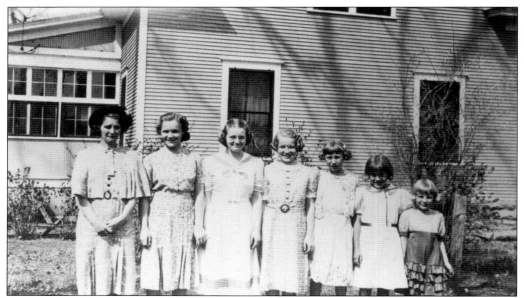

Charles O. Plumb snapped this photograph of his wife, Charlotte, and six daughters on the south side of their home, 955 Thirty-Ninth Avenue, around 1933. From left to right are Isabel, Charlotte, Marjorie, Barbara, Agnes, Annabel, and Frances. In 1881, Col. Charles A. White, Plumb's grandfather, applied for 160 acres through the 1873 Timber Culture Act. This 1907 eight-room, $2,500 country home, designed by Bessie Smith, was pre-wired in anticipation of electric lines being extended into west Greeley in the 1920s. The property is a Colorado Centennial Farm and is listed in the Local, State and National Registers of Historic Places.

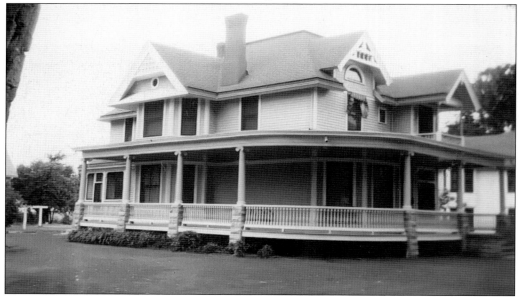

In 1893, David Gale constructed this home at 925 Eleventh Avenue where his daughter Katherine and Charles N. Jackson were married in November. The Jacksons resided here for many years. Charles worked for the Weld County Savings Bank for 62 years and played trumpet with the Greeley Philharmonic Orchestra. This home was razed in 1960 to construct the new Greeley Post Office.

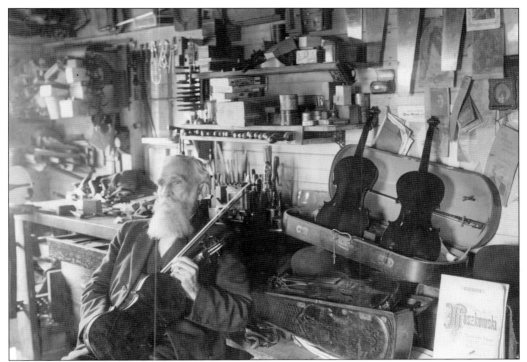

George W. Fisk, a mechanic, served as a musician in the Civil War and moved to Greeley in 1876. He played violin in local orchestras and ensembles and began producing violins in his home workshop at 714 Twelfth Street. In 1898, Hungarian virtuoso Edouard Remenyi proclaimed he was one of the preeminent luthiers in the world. Known as the "Stradivarius of the West," he had crafted 162 violins by the age of 79 in 1917.

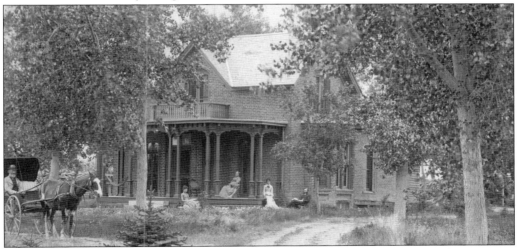

Samuel D. Hunter lived in Greeley from 1870 to 1894 and as a banker, capitalist, and stockman invested $120,000 in Greeley projects, including the Opera House and Park Place blocks, the Oasis Hotel, and the first artesian well. He owned 50 houses in Greeley, and his home, seen here at 1536 Eighth Avenue, was the first brick residence built in town. Several proprietors operated the Pines Tea Room here between 1933 and 1941.

John M.B. Petrikin arrived in Weld County on July 2, 1881. He worked on John Painter's Lost Creek ranch and later worked as a clerk and pharmacist at three drugstores. He took a job at Greeley National Bank from 1891 to 1896 and then served as Greeley's postmaster until he was offered an assistant cashier's job at the First National Bank in 1900. He served as president there from 1919 to 1955. He walked daily from his hilltop home to work and refused rides from those who offered him a lift. He died in 1957.

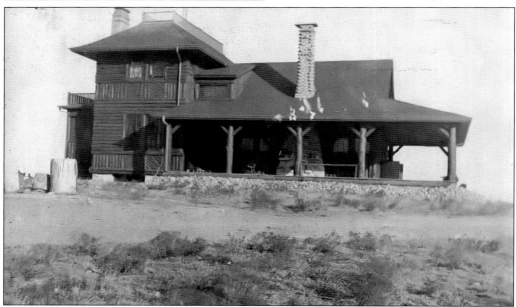

In the 1890s, John M.B. Petrikin purchased 160 acres south of Twentieth Street on a knoll known as "Rattlesnake Hill" or "Inspiration Point." In 1896, he married Gov. Benjamin H. Eaton's daughter, Jennie, and the couple built this rustic home. Jennie died in 1906, and Petrikin married Katherine Norcross Gale in 1908. The home was remodeled and enlarged in 1911. John retained the native prairie flora on the hill surrounding his home, which was razed in 1963 for the construction of the Student Center at Colorado Teachers College.

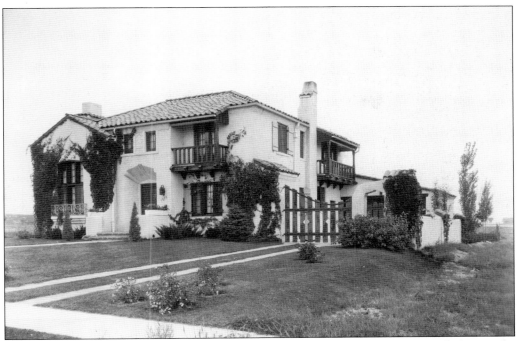

Contractor Otto F. Stoffgren built this Mediterranean-style home at 1919 Fourteenth Avenue for $10,000 in 1931, purchased by David B. Bier and his wife, Lillian, in 1932. Bier was a partner and manager at the Greeley Ice and Storage Company, established the Greeley Creamery Company with Harvey Parker, and organized the First Industrial Bank with Frank Fields.

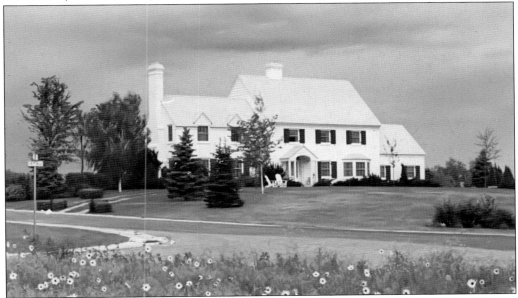

Frank Weller established the Fairacres subdivision in 1938 and built his Colonial Revival home here at 1911 Glenmere Boulevard. Fairacres had curved drives, curb sidewalks and paving, and water and sewer connections in place before lots were sold, and property deeds had no restrictive liquor clause. Fairacres was dubbed "Pill Hill," as many doctors and professionals lived here.

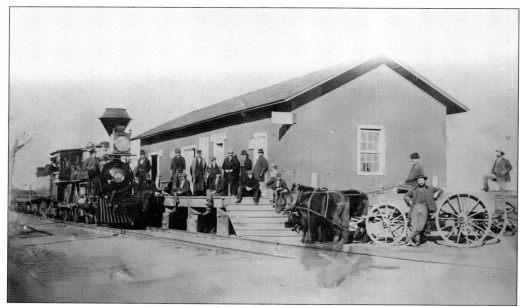

In the spring of 1871, this 60-foot-long depot replaced the boxcar used as Greeley's first depot. It was located near Eighth Street and Seventh Avenue. Most colonists and their household goods arrived by train. Abner S. Baker, the founder of Fort Morgan, Colorado, is seated in the wagon.

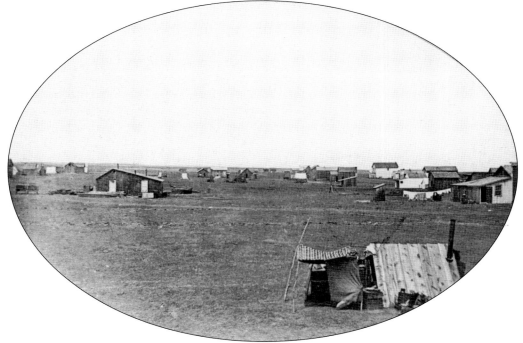

This 1870 view of Greeley between Eighth and Ninth Streets was taken looking west from the railroad tracks. The tent was the temporary home of Job and Martha A. Brownell. The Hotel d' Comfort (dubbed "discomfort"), its rear visible to the right of the clothes on the line, provided cramped, hot communal lodging for Greeley's first arrivals.

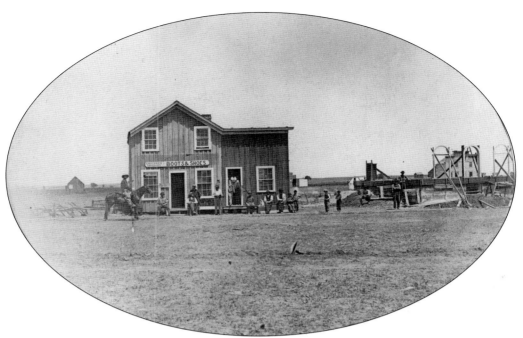

Greeley's first commercial buildings in 1870 were Monk's Boots and Shoes and the Emerson, West, and Buckingham Bank, under construction at the right.

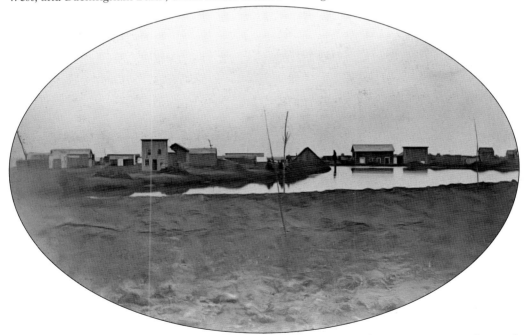

Trees resembling buggy whips and the newly dug crescent-shaped Lake Luna are seen in the south part of Lincoln Park looking east towards Ninth Avenue on July 4, 1870. Named by Edwin S. Nettleton, the ear-shaped Lake Auricular was in the north section of the park. Both were filled in by 1880 due to stagnant water problems and abundant mosquitoes.

The Main (Eighth) Street lateral, seen in this July 4, 1870, view looking east from Tenth Avenue, carried water from Ditch No. 3 south of town into Lincoln Park.

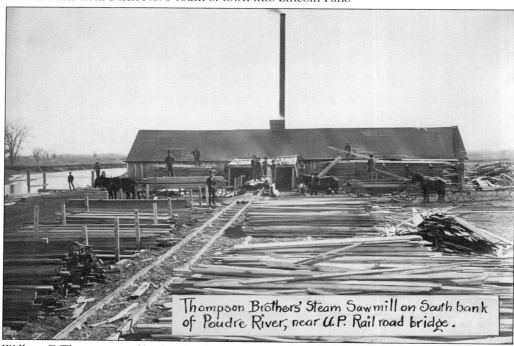

Thompson Brothers' Steam Sawmill on South bank of Poudre River, near U.P. Rail road bridge.

William F. Thompson and his brother, James, operated a sawmill for a few years on the south bank of the Cache la Poudre River between the Eighth and Eleventh Avenue bridges. By the mid-1870s, head gates of numerous irrigation ditches made it difficult to drive logs down the Poudre during the spring runoff. In 1873, William's customers who paid their bills by the 30th of the month paid less: $23 per thousand board feet for common lumber.

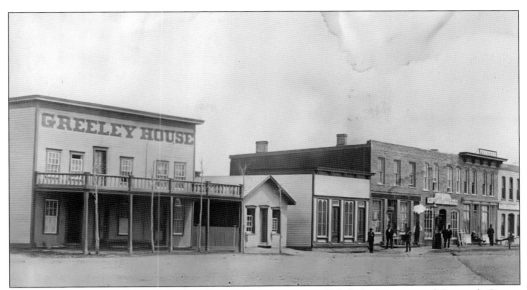

A former Evans hotel was moved to the northeast corner of Eighth Avenue and Seventh Street and was named the Greeley House. The hotel had 11 bedrooms with black walnut furniture and chamber sets. A fire on March 6, 1880, destroyed the hotel and other businesses on this block.

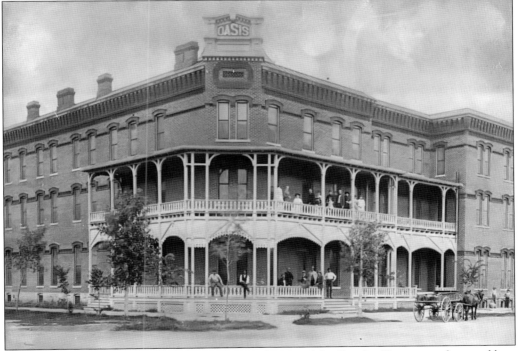

The $25,000 Oasis Hotel, built in 1881–1882 on the site of the Greeley House, was financed by a stock company of prominent businessmen. It had 40 sleeping rooms with four bathrooms located on the second and third floors, separate parlors for men and women, a billiards room with four tables, sample rooms used by traveling salesmen, Brussels carpeting, electric bells, gas lights, steam heat, a restaurant, and its own artesian well.

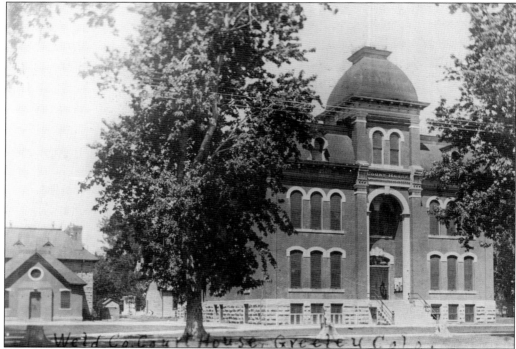

The Weld County Courthouse, constructed in 1883–1884 for about $130,000, was designed by Denver architect Frank E. Edbrooke. The two-story, 30-foot-by-40-foot stone jail and jailor's residence, to the left, were built for $6,200 in 1885–1886 and replaced the brick 1874 jail. The May 5, 1886, *Greeley Tribune* reported that not even one of Weld County's 10,000 residents was occupying the commodious and substantial jail, making it a "county luxury, so to speak."

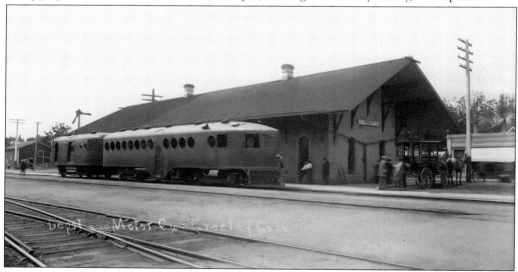

A new 30-foot-by-60-foot stone depot with separate men's and women's waiting rooms was built east of Seventh Avenue at Ninth Street for $15,000 in 1883. McKeen motor car M-12, seen in this c. 1911 image, was a cost-efficient distillate-burning vehicle used for service on the Union Pacific's Pleasant Valley and Crow Creek branch lines northeast of Greeley.

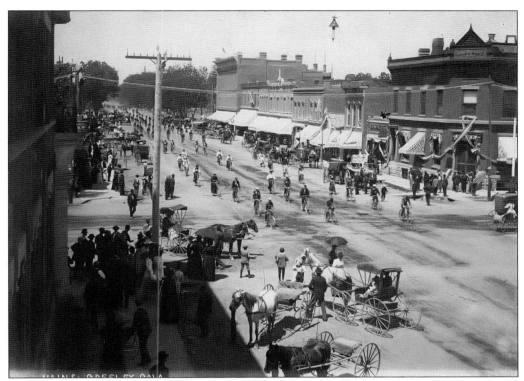

Stores on the north side of Eighth Street between Eighth and Ninth Avenues are decorated with flags and bunting for a firemen's tournament and bicycle parade on July 4, 1902.

This c. 1909 image shows Ninth Avenue looking north from the intersection of Eighth Street. New trees (right) are seen between the stumps on the east side of Lincoln Park, and city hall and the fire bell tower (top left) are at the corner of Seventh Street and Ninth Avenue. The Greeley Business College, above the Kittle & Whitney Grocery, adjoined the Park Place building on the right.

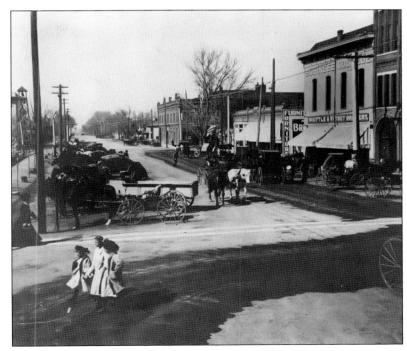

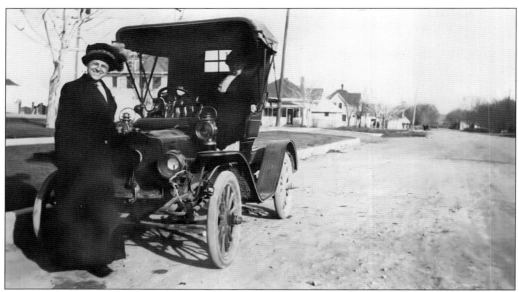

Dr. Ella Mead (standing) made house calls on her bicycle until she purchased this 1906 Maxwell, which she maintained by doing her own mechanic work. She received her degree in 1903 and established her office in the Coronado Building. As city health officer, she maintained vital statistics for Greeley and Weld County and in the 1930s started one of the first birth control clinics in the country. The National Medical Women's Association honored her achievements in medicine and public health when she received the Medical Woman of the Year award in 1958.

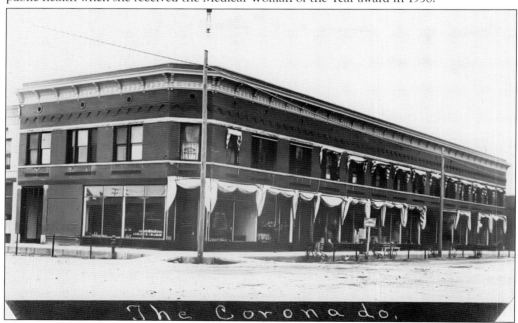

The Coronado Building, designed by Bessie Smith, was built at the southeast corner of Ninth Street and Ninth Avenue for $40,000 in 1906. Owned by Judge John T. Jacobs, Dr. Robert Graham, and Robert Steele, retail businesses occupied the first floor while the second floor became the preferred address for doctors, dentists, lawyers, and other professionals.

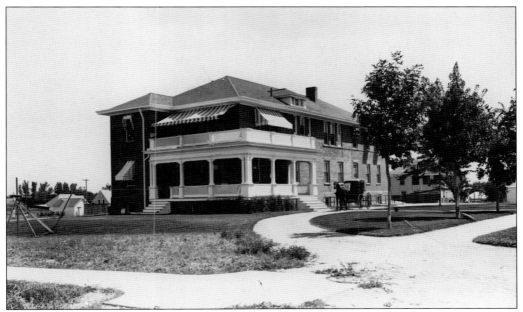

In 1903, Robert S. Roeschlaub designed two Weld County hospitals. The Greeley Hospital, at 1027 Sixteenth Street, was the "pay branch" and opened on May 7, 1903. A double room cost $12.50 per week, and private rooms cost $15 to $25 per week. It was later enlarged. The other hospital, Weld County Hospital, opened in 1903 at Island Grove Park and provided indigent care.

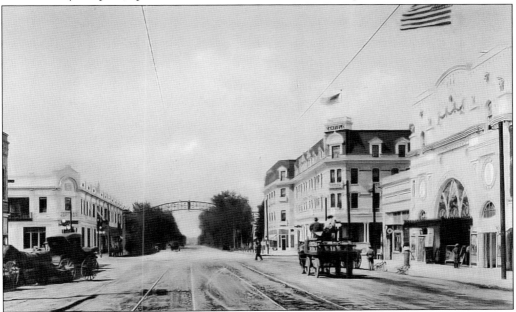

This c. 1915 view of Eighth Avenue looking north from Eighth Street shows the 1915 Rex Theater and the Oasis Hotel (right). Daniel A. Camfield purchased the Oasis in 1906, renovated it, built an addition, and renamed it the Camfield. The City National Bank was located in the 1911 Camfield Court Building (left). Camfield installed a lighted welcome arch that stood over Eighth Avenue from 1911 to 1917. Tracks and electrical wires for the streetcars are visible.

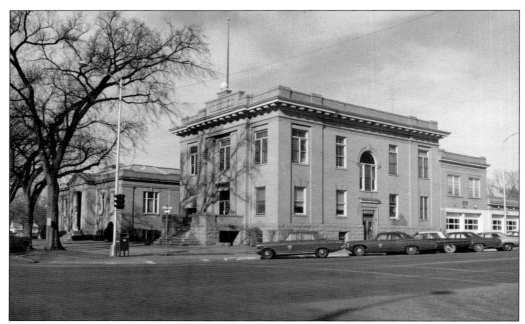

Greeley had a population of 6,000 in 1907, and with 38 municipal employees, the town had outgrown the small frame city hall built in 1879. This is Greeley's second city hall, with an attached fire station, built in 1907–1908 at the northwest corner of Ninth Avenue and Seventh Street.

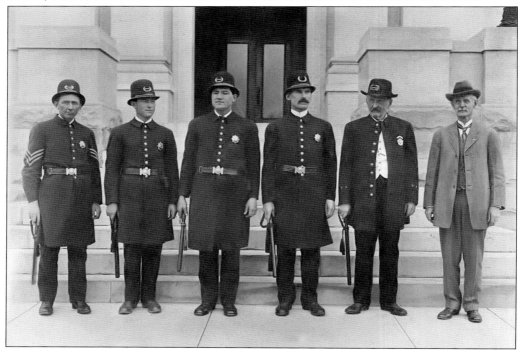

Officers of the Greeley Police Department pose for this 1911 photograph in front of city hall. From left to right are William H. Ahrend, three unidentified men, Marshal Dave Camp, and Mayor William Mayher.

The third Weld County Jail included the sheriff's living quarters, cost $50,000, and was designed by Frank E. Edbrooke of Denver. It was built in 1911–1912 between the courthouse and the Elks Lodge on Ninth Street. The March 4, 1912, *Greeley Tribune* reported that "Sheriff McAfee is clothing prisoners in a blue jumper and overalls and a pair of felt slippers to wear while they are the guests of the county," as "sanitary suits" were easier to keep clean.

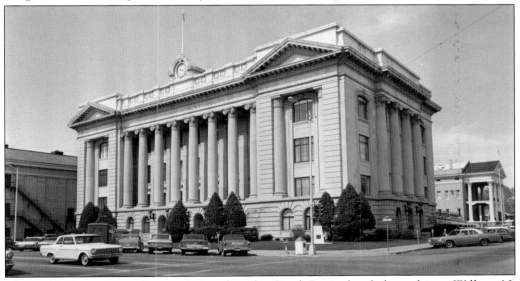

The Weld County Courthouse, designed in the Greek Revival style by architect William N. Bowman of Denver, was constructed in 28 months and is one of Colorado's most beautiful county buildings. A building fund created by the Weld County commissioners and a tax levy for the years 1914 to 1916 eliminated the need for construction bonds. The furnished $414,302 building was completely paid for when it was dedicated on July 4, 1917.

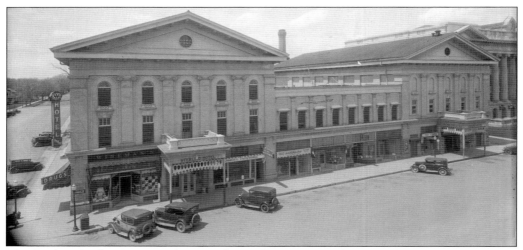

The Sterling Realty Company (Asa Sterling, John M. B. Petrikin, Joseph C. Ewing, and James G. Milne Sr.) financed the construction of the Sterling Hotel and Theater in 1910–1911 on the west side of Ninth Avenue south of the courthouse. Designed in the classical style by Greeley architect Wayne Patterson, it was constructed of special bricks from Ohio.

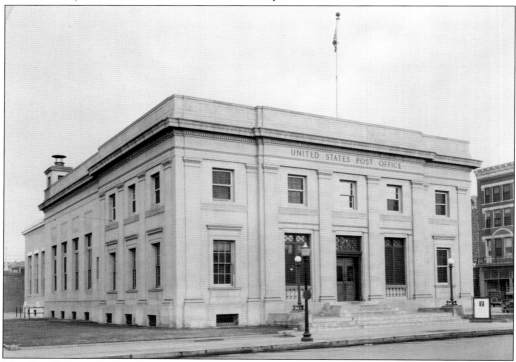

The Greeley Post Office rented space in various buildings until November 1915, when this new fireproof post office with keyed mailboxes opened at the northeast corner of Eighth Street and Eighth Avenue. Modeled on a federal building in Kearney, Nebraska, the exterior was constructed of Bedford limestone, with Colorado and Georgia marble used in the interior. In spite of citizens' protests, it was razed in 1962 for the construction of the new Denver Dry Goods Company department store.

The Greeley & Denver Railroad Company, a corporation of local businessmen, financed a streetcar line built by Greek and Italian laborers in 1909. Seven thousand people enjoyed free rides over 3.5 miles of streetcar tracks when the line opened on May 30, 1910. A $35,000 fire on November 23, 1917, destroyed the company's car barn and equipment, and it was bankrupt by November 1922, unable to pay thousands of dollars in back taxes, employee salaries, and power bills.

By 1929, Eighth Avenue was Greeley's "motor row," teeming with automobile dealerships, service stations, and repair shops. The Ford dealership (right) was founded in December 1922 by Hugh F. Wheeler and William Garnsey at Eighth Avenue and Eleventh Street.

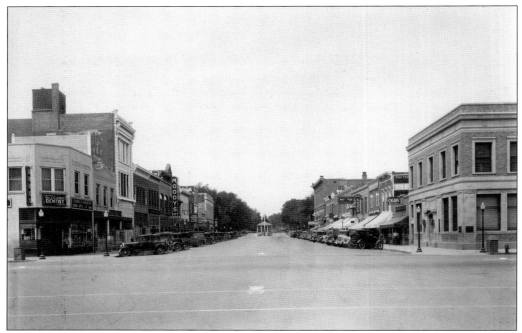

This is a 1929 view of the 800 block of Eighth Street looking west from Eighth Avenue toward Lincoln Park. In 1983, Eighth Street between Eighth and Ninth Avenues was closed to create a pedestrian mall.

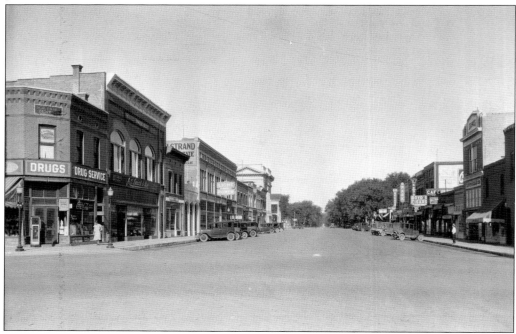

This is a 1929 view of the 800 block of Ninth Street looking west from Eighth Avenue toward Lincoln Park and the Weld County Courthouse. This block between Eighth and Ninth Avenues was closed to create a second pedestrian mall in 1983.

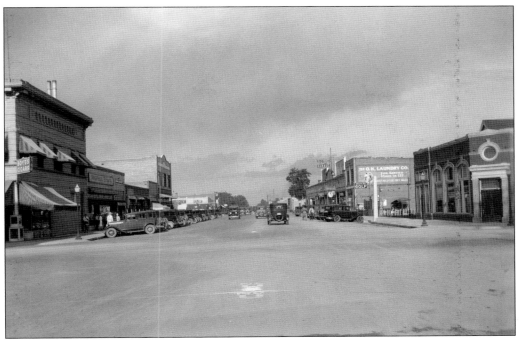

Looking east on Tenth Street from Ninth Avenue in 1929, the Greeley Gas Company is seen on the right, and Boyd's Cigars, located in the 1908 Marlborough Building, is on the left. Paul Darrow, son of famous trial lawyer Clarence Darrow, was the president of the gas company.

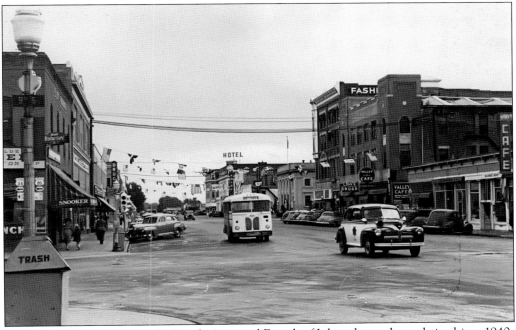

Eighth Avenue is decorated for Greeley's annual Fourth of July rodeo and parade in this c. 1940s image looking north from Ninth Street. Private bus companies operated in Greeley from the 1920s until 1959, when the city purchased the Greeley Bus Company from William Wingo.

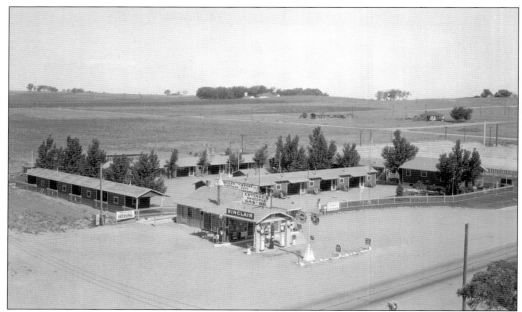

The orange-and-blue Greeley Airport Cottage City, at 2425 Eighth Avenue, was built in 1927 by J. Fred Starkey for the motoring public and operated until 1942. The Starkeys provided local weather information six times a day to the Cheyenne and Denver airports. In 1921, city aldermen approved leveling off five square blocks at 2500 Eighth Avenue for a municipal landing field. A new airport opened east of Greeley and was dedicated as Crosier Field in September 1944.

The north half of Lincoln Park was flooded for ice skating, and businesses at Ninth Avenue and Seventh Street are reflected in the melting ice in this c. 1930s image.

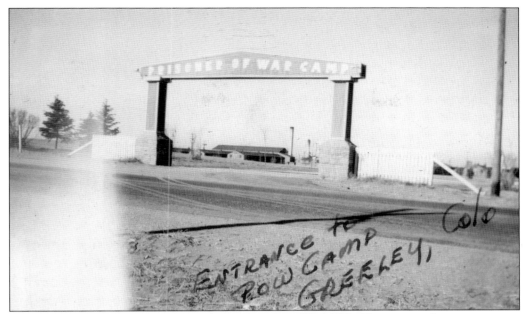

This was the entrance gate into Greeley Camp 202, a World War II prisoner-of-war internment camp located eight miles west of Greeley north of Highway 34. It was built in the fall of 1943, cost $1.5 million, and was under the command of the 9th Division of the Army, with headquarters at Omaha, Nebraska. About 4,000 German and Austrian soldiers arrived here in March 1944. The camp closed in 1946.

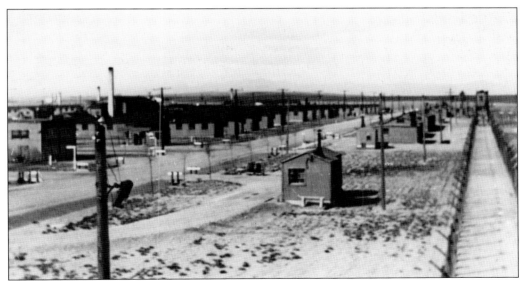

Prisoner barracks and a 12-foot area patrolled by attack dogs between 14-foot-high security fences and a guard tower are seen in this photograph of Camp 202. This 320-acre facility had all the amenities of a modern city and could accommodate 3,600 people. There were 60 prisoner and 16 US Army personnel barracks. Prisoners worked on local farms and were treated and fed so well that locals called the camp the "Fritz Ritz." The camp was quickly dismantled and buildings and materials salvaged and sold for other uses after 1946.

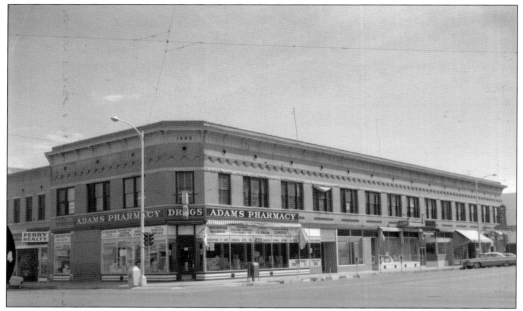

Greeley native William C. Adams graduated from the Babcock School of Pharmacy in 1922 and worked as a pharmacist at the Clark and Faulkner Drug Store from 1923 to 1944. He opened Adams Pharmacy at 900 Ninth Street in 1944 and retired in 1971. The contents of his store were purchased by Carroll Gilbert, owner of the Weldorado Drug Store at 800 Ninth Street.

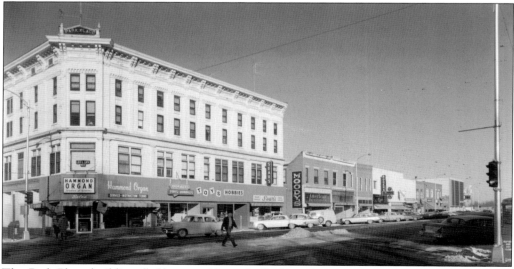

The Park Place building (left), east of Lincoln Park at the intersection of Eighth Street and Ninth Avenue, was built by Samuel D. Hunter in 1885 for $40,000. Cattleman Bruce Johnson established the Park Merchandise Company here. The commodious third floor hall housed the Greeley Elks Club from 1902 to 1912 and, prior to World War I, the YMCA gymnasium. In 1919, J.W. Norcross, Frank Neill, and Joseph "Toots" Mondt, an ex-farmer turned wrestling champion and promoter, rented the hall for wrestling matches. Mondt wrestled Ad Santel here, and 1,399 spectators packed the premises on July 4, 1921, to watch Japanese jujitsu champion Taro Miyake wrestle Canadian Jack Taylor.

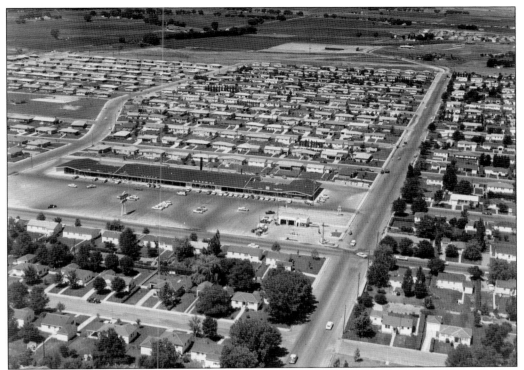

Hillside was developed between 1952 and 1958 on the 1884 homestead where William H. Farr raised hay and barley and fed sheep. Growth and a strong economy inspired the Farr family to transform the farm into a residential neighborhood with a park, a pool, and a commercial district. The Homestead Corporation, comprised of John R.P. Wheeler, Hugh Phillips, Howard Murphy, and Carl Hill, oversaw its development. Ranch-style homes sold for $5,000–$8,000. Hillside Center (center), Greeley's first shopping mall, was built in 1958 and included Safeway, Hested's, Gilbert's Pharmacy, and later, Stockfleth's Hardware.

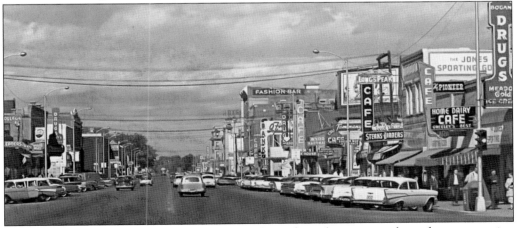

Highway 85 became Eighth Avenue through Greeley and was the major north-south transportation route between Denver and Cheyenne. This view, looking north from Tenth Street in 1955, is dense with restaurants, cafés, and businesses, as Greeley was northern Colorado's premier retail center prior to the development of Interstate 25.

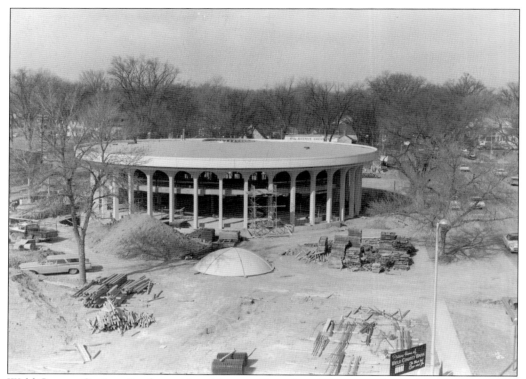

Weld County Savings Bank president Norman Dean hired Denver architect Marvin Knedler to design a distinctive bank at 1000 Tenth Street. Hensel Phelps Construction Company solved complicated engineering and structural problems to preserve the feel of offices floating within an open round arcade. It opened on October 1, 1968, and became United Bank of Greeley in 1970. The City of Greeley purchased the building for $1.57 million in November 1987. It became the new city hall in February 1988.

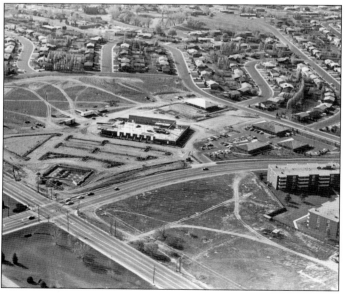

Advertised as Greeley's finest commercial and professional center, Cottonwood Square at Sixteenth Street and Twenty-Third Avenue was in the planning stage for eight years as its developers, John C. Todd and Robert L. "Larry" Eaton, overcame zoning disputes, high interest rates, and rising construction costs. Toddy's, an upscale 37,500-square-foot grocery store (center), and Midland Savings (left near the intersection) are under construction in this 1976 photograph. Toddy's opened on February 13, 1977, and closed on February 12, 2004.

Dorothy Martin Zabka, Greeley's only woman mayor, served two terms, 1965–1969. During her tenure, Greeley voters approved the sale of alcohol within the city limits and financed and built the Civic Center Complex, and highway bypasses were constructed around Greeley. Zabka attended Barnes Business College in Denver in the 1940s and worked at Martin Produce, which she successfully managed for 10 years after her father, Henry, died in 1947. With her extensive background in agriculture and business, for decades, she was an active leader in Weld County's 4-H programs and the county fair.

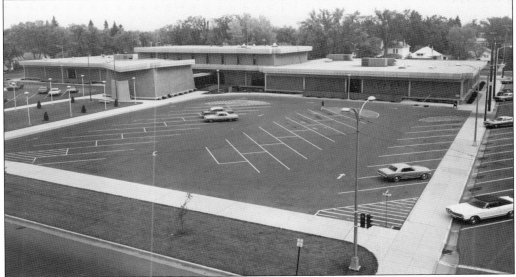

The new $1,015,900 Civic Center Complex, designed by Greeley architect C. Neal Carpenter with Bill Williams and Howard Johnson, was dedicated on March 3, 1968. Mayor Dorothy Zabka proclaimed, "This is the beginning of our urban downtown renewal program." Municipal offices, the Greeley Public Library, the police and fire departments, and the city council chambers were housed in the 60,300-square-foot building. The library, fire station, and other offices were moved in 2016, as the complex will be razed when a new downtown hotel and convention center opens on this site in 2017.

DISCOVER THOUSANDS OF LOCAL HISTORY BOOKS
FEATURING MILLIONS OF VINTAGE IMAGES

Arcadia Publishing, the leading local history publisher in the United States, is committed to making history accessible and meaningful through publishing books that celebrate and preserve the heritage of America's people and places.

Find more books like this at
www.arcadiapublishing.com

Search for your hometown history, your old stomping grounds, and even your favorite sports team.

Consistent with our mission to preserve history on a local level, this book was printed in South Carolina on American-made paper and manufactured entirely in the United States. Products carrying the accredited Forest Stewardship Council (FSC) label are printed on 100 percent FSC-certified paper.

MADE IN THE
USA